IMAGES
of America

HAMPTON'S
OLDE WYTHE

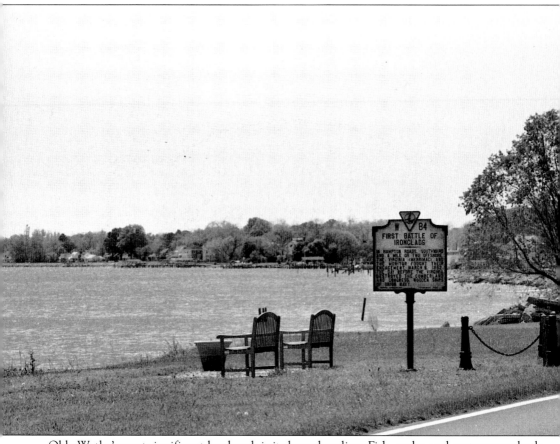

Olde Wythe's most significant landmark is its long shoreline. Fish, crabs, and oysters were both food and the foundation of late-19th- and early-20th-century economies. Residents found the summer breezes a relief in a sticky climate. Ports and shipyards were profitable for the whole area and attracted concentrations of military might afloat and ashore. Whether sunny blue waves or stormy tempests, the waterway is Olde Wythe's soul. (Courtesy Carol King.)

ON THE COVER: Capt. John C. Robinson and fellow seafood entrepreneurs shipped fresh crab all over the country using a process developed in Hampton by James McMenamin. One of the key reasons for their success was an emphasis on sanitary packing conditions. Note the pickers' mobcaps and the careful handling of the crabs waiting to be picked in this 1910 advertising photograph. (Courtesy Beverly Robinson.)

IMAGES
of America

HAMPTON'S OLDE WYTHE

The Olde Wythe Neighborhood Association

ARCADIA
PUBLISHING

Copyright © 2006 by the Olde Wythe Neighborhood Association
ISBN 978-0-7385-4330-7

Published by Arcadia Publishing
Charleston SC, Chicago IL, Portsmouth NH, San Francisco CA

Printed in the United States of America

Library of Congress Catalog Card Number: 2006927028

For all general information contact Arcadia Publishing at:
Telephone 843-853-2070
Fax 843-853-0044
E-mail sales@arcadiapublishing.com
For customer service and orders:
Toll-Free 1-888-313-2665

Visit us on the Internet at www.arcadiapublishing.com

This book is dedicated to George Wythe. His father and grandfather were major landholders in Colonial Elizabeth City County. He was born in 1726 or 1727 and raised at the family estate of Chesterville, now on the grounds of NASA/Langley. Wythe became a lawyer in 1748 and an elected burgess (Colonial legislator) in 1754. In the 1760s, he mentored the young Thomas Jefferson in law. Although a close friend of several English governors, he opposed the Stamp Act and attended the Second Continental Congress in 1775. His signature appears first among the Virginians on the Declaration of Independence. In 1779, the College of William and Mary appointed him professor of law and police. He disapproved of slavery, freeing several of his own slaves and leaving bequests in his will to three he had already freed. Wythe set an example of moral character, intellectual endeavor, and public service for the people of Olde Wythe, Hampton, and Virginia.

CONTENTS

ACKNOWLEDGMENTS

This book would not have been possible without the resources and generous help of the following: Theresa Hammond of the William E. Rouse Library, Mike Cobb and Barbara Boyer of the Hampton History Museum, the library staff and Claudia Jew of the Mariners' Museum, David Johnson of the Casemate Museum, Vanessa Thaxton-Ward and Donzella Maupin of Hampton University, John Quarstein and George Hoffeditz of the Virginia War Museum, Gaynell Drummond and Elizabeth Wilson of the Hampton Public Library's Virginiana Room, Dr. Paul McAllister and Dr. Edward Longacre of the historian's office at Headquarters Air Combat Command, and Tracy Sorensen and Dennis Tenant of the *Daily Press*.

The authors are also grateful to the Oasis Restaurant for helping publicize the project; Camera City, Inc., for their expert handling of old pictures and documents; Ron Quinn for his architectural expertise; Clyde Williams for mentoring the team; and the Board of the Olde Wythe Neighborhood Association for consistent and enthusiastic support, both of the project and the team.

Finally the largest vote of appreciation goes to all the residents, past and present, who dug into their memories, scrapbooks, attics, garages, and yearbooks for the raw materials that are truly the bones and blood of this book. Hundreds of people trusted us with their treasures in order that Olde Wythe's story could be told. Thank you every one.

INTRODUCTION

When English colonists erected the first fort on the Lower Peninsula of the James and York Rivers in 1609 and removed the local American Indians in 1610, they started the oldest continuously inhabited English-speaking community in the United States. Elizabeth City County was one of the first eight Virginia counties set up in 1634, named for the daughter of King James I. As a curious twist, there never was an Elizabeth City in the county; instead the Virginia Assembly created a town and customs district in 1691 and named the town Hampton in 1706 in honor of the Earl of Southampton. Elizabeth City County continued, with Hampton as its seat, until 1952, when the citizens voted to merge into the City of Hampton with no county.

The Olde Wythe Neighborhood is bounded by Kecoughtan Road, the Hampton Roads waterway, the Newport News line at Pear Avenue, and La Salle Avenue. It contains some 1,600 households. Hampton's Greater Wythe Neighborhood District is an administrative entity that includes Olde Wythe, extends north to Pembroke Avenue, and has a population of 13,800. In order to include all the relevant history, this text relies on older, similar boundaries: the Hampton Roads waterway, Pembroke Avenue/Shell Road, Church Creek east of La Salle Avenue, and Salters Creek in Newport News.

After the Revolutionary War, the present Wythe area was simply county farmland with no special designation, though it had strategic value for military operations and economic value for the declining port of Hampton. Fort Monroe, built on the Old Point Comfort site fortified first in 1609, was the Union's cornerstone for Civil War military operations in Tidewater Virginia. It was a bastion protecting the Union fleet and setting the stage for the Battle of the Ironclads in 1862. The Civil War saw Hampton burned and sent county landowners into exile, leaving their property open to squatters. After the enormous demographic and economic changes of the Civil War, Elizabeth City County was divided into three new districts: Chesapeake, Southfield, and Wythe. By 1900, these had been streamlined to Chesapeake and Wythe, divided at King Street extended, in addition to the town of Hampton. This division remained the status quo until 1952.

The Hampton Normal and Agricultural School opened in 1869 to train young freed black men and women in useful trades. It attracted many well-educated Northerners who contributed to the growth of Wythe by their investments in land and industry. A decade after Gen. Samuel C. Armstrong founded the school, his brother Col. William N. Armstrong and William's wife, Mary Frances, came to help the school and began building their real-estate holdings. Other Northern newcomers, such as Charles E. Hewins and John C. Robinson, saw not only the chance to make money but also to help rebuild a fractured society and economy. These leaders were key to the growth of modern Wythe and joined with James S. Darling, James McMenamin, and others to develop the economy of Elizabeth City County.

The next major historical theme began with another entrepreneur, Collis P. Huntington. Soon after the Civil War, he bought up land in Newport News and its county of Warwick, mostly at depressed prices. In 1881, he brought the Chesapeake and Ohio Railroad to the Lower Peninsula,

first to the expanding port on the James River and then to Hampton and Fort Monroe. Soon after, he opened the Chesapeake Dry Dock and Construction Company, which attracted skilled laborers, senior managers, investors, and associated support services. This influx, which encouraged the growth of streetcars, electric service, and Wythe's residential development, continued through World War I.

World War I brought a number of important changes to the Lower Peninsula. The Hampton Roads U.S. Army Port of Embarkation at Newport News shipped troops, horses, and cargo; stressed local transportation and housing; and also attracted yet more skilled laborers. Langley Field came into being in 1917, combining initiatives from the National Advisory Committee for Aeronautics and the U.S. Army for test and training facilities.

The interwar years saw further residential development and the destruction of the Chesapeake Avenue streetcar line in the storm of 1933. World War II brought new troop ship and cargo demands to Hampton and Newport News, including military training camps and an aircraft-spotting unit located in Wythe. During and after the war, the Wythe business district blossomed. It had its own business association, new-style shopping center with a movie theater, and such well-loved social establishments as Bill's Barbecue and the bowling alley. Most churches, schools, and shops in Wythe were specifically white then, with black residential sections along Shell Road.

In the 1970s, developmental trends in Hampton and Newport News overtook Wythe, bringing racial integration to housing, voting, and schools. New economic magnets emerged elsewhere on the Lower Peninsula and in the Hampton Roads area, fueled by the 1950s interstates and the Hampton Roads Bridge-Tunnel.

Today the future is one of preserving the charm of the past, with homeowner restorations and civic investment in Olde Wythe, and of developing new models for residential and business patterns in 400-year-old Hampton.

One

Indians, Farmers, and Northern Newcomers

Before the first Europeans arrived, the Wythe area was home to the Kecoughtan Indians, part of Powhatan's chiefdom. Their small village occupied a fertile point at the entrance to Hampton Roads, where they fished, raised corn, and were hospitable to visiting 16th-century Spanish Jesuits and to the English in 1607. In 1610, the Virginia Company of London began a settlement there; it was laid out as a town in 1691, was named Hampton in 1706, and became one of the busiest ports in early-18th-century Virginia.

The only significant establishment in Colonial Wythe was Celey's Plantation, from Salters Creek to roughly Claremont Avenue. Other farms included the one where the British landed for their flank attack on Hampton in 1813. Land was subdivided until the average county farm was less than 50 acres by the Civil War, though George M. Bates and John Simpson amassed considerably more than the average in the present Olde Wythe area.

In 1861, Confederate troops, including many Hampton residents, burned the town to deny it to the Federals at Fort Monroe. Fleeing slaves, called "contrabands," soon flooded ruined Hampton and the county. The most remarkable event of the war in Wythe was the battle between the ironclads USS *Monitor* and CSS *Virginia*, fought off Salters Creek with residents watching wide-eyed.

Elizabeth City County's self-government disappeared during the Civil War, with no court minutes recorded between May 1861 and November 1865. County demographics changed enormously during this time thanks to the burning and evacuation of Hampton and the huge influx of freedmen. Postwar Yankee investors along the water were Capt. John C. Robinson, who set up a seafood plant and a brick enterprise; Capt. Charles E. Hewins, who invested in oysters and land; and the Armstrongs, who obtained lands east of Hewins. Daniel Cumming also entered the real-estate lists, buying up the Simpson lands and others for his Otley estate further east. Lastly the old Celey lands (west end) passed into developers' hands around 1890. Meanwhile, Newport News' industrial growth was creating a demand for labor, housing, and transportation. Thus the stage was set for the next chapter in Olde Wythe history.

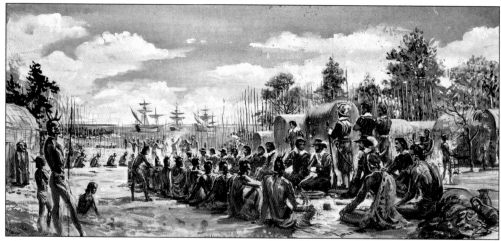

This Sidney King painting shows the arrival of the English at Kecoughtan on April 30, 1607. The 20 or so village families provided food and hospitality—and an occasional fight—until the English drove them off on July 9, 1610. The first Colonial settlement was a collection of scattered dwellings along the Hampton River. (Courtesy Hampton History Museum.)

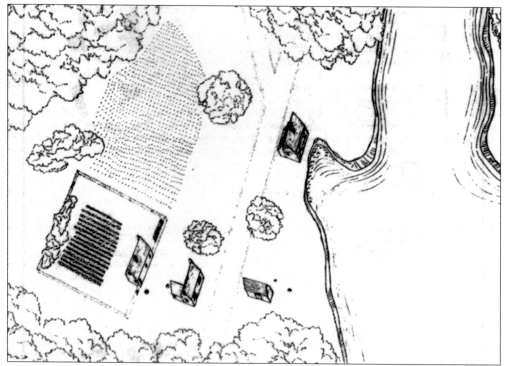

This artist's conception shows a 17th-century impermanent post-in-ground home and tavern excavated at the site of the Hampton Carousel and Virginia Air/Space Center in downtown Hampton. The archaeologists consider that simple structures along the creeks of the Lower Peninsula would have looked much like these. (Courtesy Hampton History Museum and the William and Mary Center for Archaeological Research.)

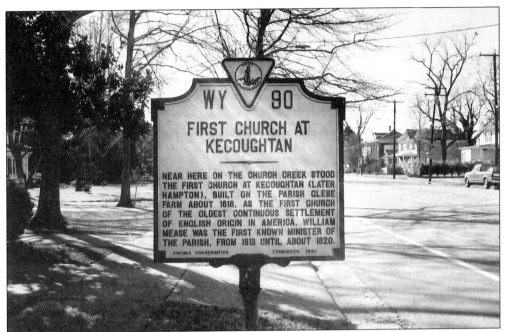

According to local tradition, the first parish church after 1610 was near Church Creek, east of La Salle Avenue. A second church (1623–1667 or so) was built east of the Hampton River, while the third church's foundations are on Pembroke Avenue, then an outlying farm area safer from pirates. In 1728, the parish moved back in town to the fourth and present church (St. John's). (Courtesy Carol King.)

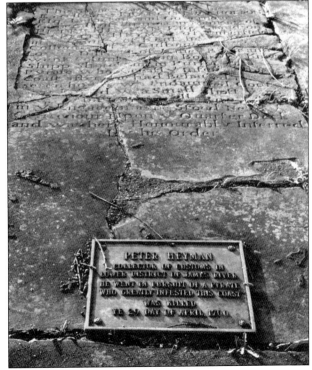

This tombstone is at the site of the third church. Peter Heymann, Esq., was a customs collector who was killed in shipboard action against a "pyrate who greatly infested this coast . . . ye 29 day of April 1700." This event presaged the January 1, 1719, defeat of Blackbeard, whose head was displayed at the entrance to Hampton River. (Courtesy Carol King.)

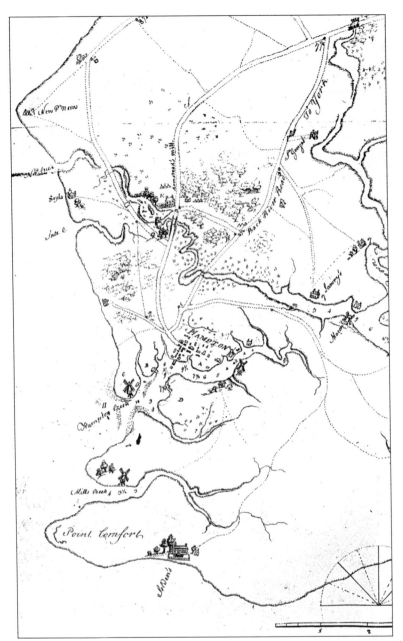

In 1782, the staff of Sir Henry Clinton compiled an extraordinary set of maps of the Chesapeake Bay. This detail shows the Colonial development of the Lower Peninsula. Celey Plantation ("Seyla" here), some 2,000 acres, was originally granted to Miles and William Pickett. It was later acquired by Maj. Thomas Celey and conveyed in 1695 by his son to Col. William Wilson. In 1706, Colonel Wilson built a two-story brick house with a white-pillared portico and terraced gardens extending several hundred feet to the waterway then known as the James River, now Hampton Roads. The address 225 Chesapeake Avenue is the closest approximation of the site today. Celey lands extended roughly to today's Claremont Avenue. The creeks on either side of Seyla are probably Salters Creek and the present Indian River. (Courtesy Clements Library, University of Michigan.)

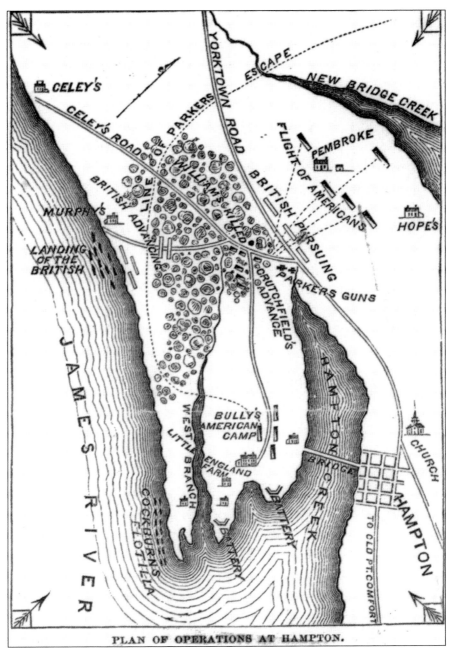

PLAN OF OPERATIONS AT HAMPTON.

On June 25, 1813, between dawn and sunrise, 2,500 British troops landed near the house of Daniel Murphy in 20–30 launches holding 50–70 men each. They were two miles away from the 450 Virginian soldiers at Little England, whose attention was distracted by British bombardment. That distance places the landings at Indian River and/or Robinson Creek, though no physical evidence is known. After crossing the tidal marshes, the British advanced along a farm road to the Celey Road (probably Shell Road). After defeating the defenders, the British went on to sack Hampton. This pillage outraged the country and helped mobilize public opinion against the invaders. (From B. J. Lossing, *Pictorial Field Book of the War of 1812*, published 1868, now in the public domain.)

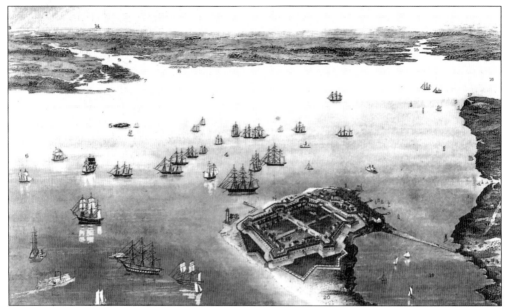

In the spring of 1861, Fort Monroe was the Union stronghold in Virginia and the guardian of vital Hampton Roads waterways. This view, reportedly drawn from an observation balloon, shows a tremendous naval force assembled under the protection of Fort Monroe and its companion, Fort Calhoun (later Fort Wool). The Confederates still held Norfolk and the Gosport Navy Yard. (Courtesy Casemate Museum.)

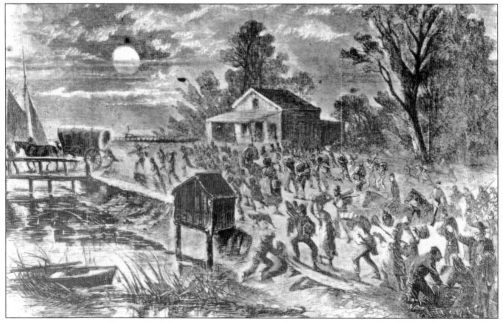

Local slaves saw the Union buildup as an invitation to freedom. On May 24, 1861, Maj. Gen. Ben Butler used a clever legal justification to rule that escaped slaves would not be returned under the Fugitive Slave Law but were instead Contrabands of War. This artist's conception shows the flood of self-freed slaves passing through Hampton to Fort Monroe, which they called Freedom's Fort. (Courtesy Casemate Museum.)

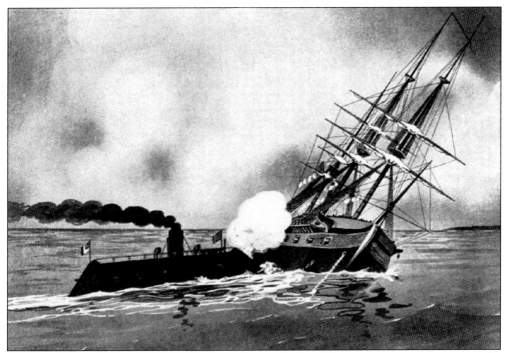

On March 8, 1862, the CSS *Virginia* emerged from the Elizabeth River. It was a conversion of the wooden frigate USS *Merrimack*, captured half-burnt in dry dock in 1861. The *Virginia* destroyed the USS *Cumberland* (shown here) by ram and the USS *Congress* by heated shot off Newport News Point. The USS *Monitor* arrived in Hampton Roads that night by the light of the burning *Congress*. (Courtesy Mariners' Museum.)

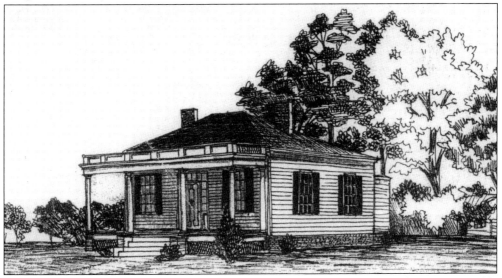

The house at 3629 Chesapeake Avenue, built by John Simpson in 1849, is the oldest in Olde Wythe. Local legend says that George Armstrong Custer watched the Battle of the Ironclads from the porch roof, though no proof of this exists. In 1866, Simpson's land became part of Daniel Cumming's Otley estate, which ran along present La Salle Avenue to Shell Road. (Courtesy Melissa Gilliland.)

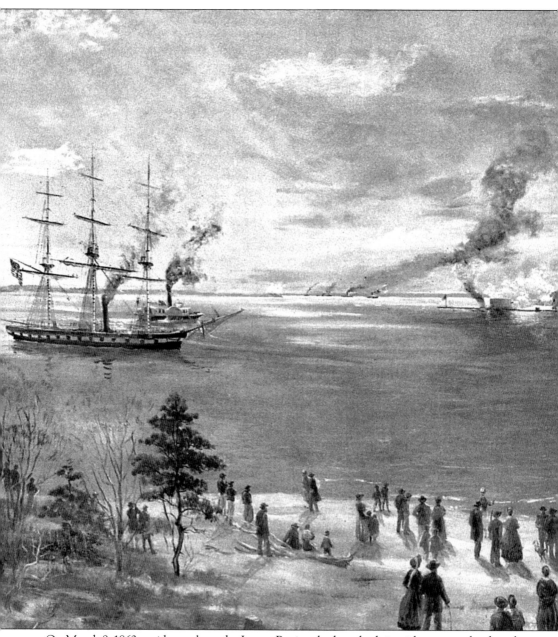

On March 9, 1862, residents along the Lower Peninsula shore had ringside seats at the showdown between the two ironclads: the CSS *Virginia*, a hybrid with a wooden hull and 22-foot draft, and the purpose-built USS *Monitor*, a revolutionary new design featuring a revolving gun turret and 10-foot draft. The shallow shores nearby played a key role this day. The *Virginia* went after the USS *Minnesota*, a wooden steam-powered frigate that had run aground the day before. The

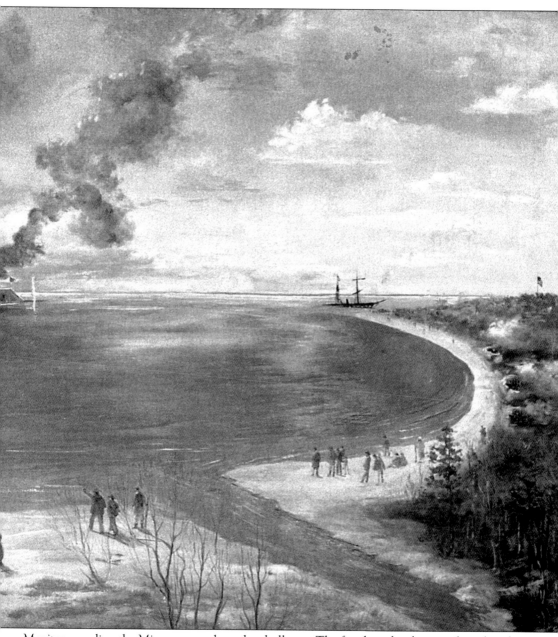

Monitor, guarding the *Minnesota*, took up the challenge. The four-hour battle was a draw, largely because of issues of draft, maneuverability, and ammunition. The true result, however, was the saving of the Union fleet and the end of the wooden fighting ship. This Sidney King painting shows the view from Salters Creek. (Courtesy Virginia War Museum.)

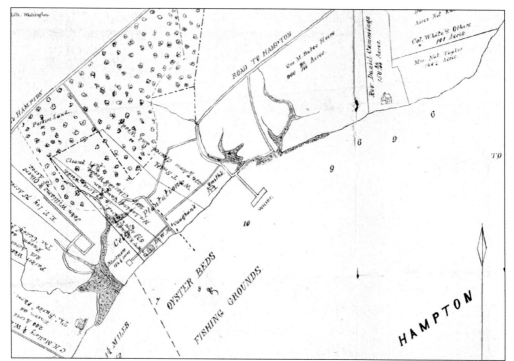

This rare map from 1870 shows the state of land ownership after the Civil War in the present Wythe area. The land of the late George Bates, along Bates Creek (Indian River), had to be sold because of probate and tax issues. Daniel Cumming's land is also shown, though not labeled as Otley here. (Courtesy Mariners' Museum.)

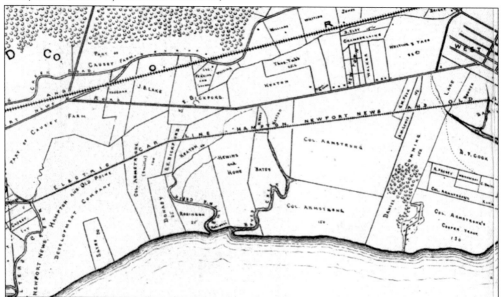

E. A. Semple, the Elizabeth City County surveyor, drew this map about 1892. It shows the major developers in Wythe: Daniel Cumming; Armstrong; Hewins and Howe; Robinson; and one of several Newport News companies. Also Lizzie Darnaby ("Donaby") bought present Claremont Avenue in 1887 and set up a tract with lots for sale in 1900. (Courtesy Library of Virginia.)

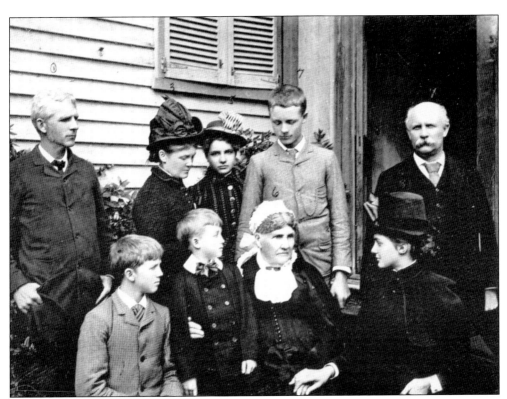

Col. William N. and Mary Frances Armstrong invested heavily in Wythe, and their sons later developed the property. From left to right in this 1887 photograph are Gen. Samuel Armstrong, founder of the Hampton Institute; Richard; Mary Frances; Kalani; Edith; Mrs. Armstrong Sr.; Matthew; Louise; and William. The young ladies are Samuel's daughters, and the boys are William's sons. (Courtesy Hampton University Archives.)

Capt. Charles E. Hewins of Dorchester, Massachusetts, was another Northerner who saw opportunity in Wythe. He went into oystering, bought property along Indian River, and built a spacious mansion overlooking Hampton Roads (2404 Chesapeake Avenue). He was a civic leader, seen in his Mason's outfit in this undated picture. (Courtesy Hampton History Museum/Cheyne Collection.)

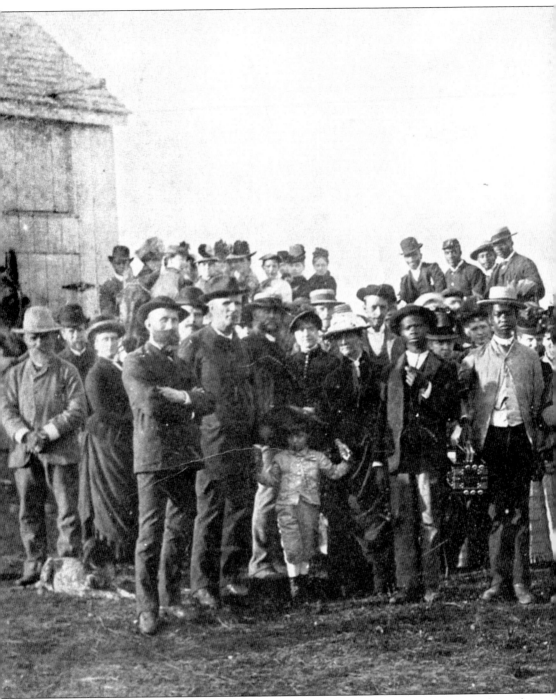

The Northerners who came after the Civil War tended to create their own society in the midst of Hampton's demographic turmoil and the economic shambles of the prewar tax base. This c. 1887 gathering was an oyster roast at Hewins's farm on Indian River. General Armstrong is the third man from the left in front, with Captain Hewins to his left. The J. S. Darlings are at

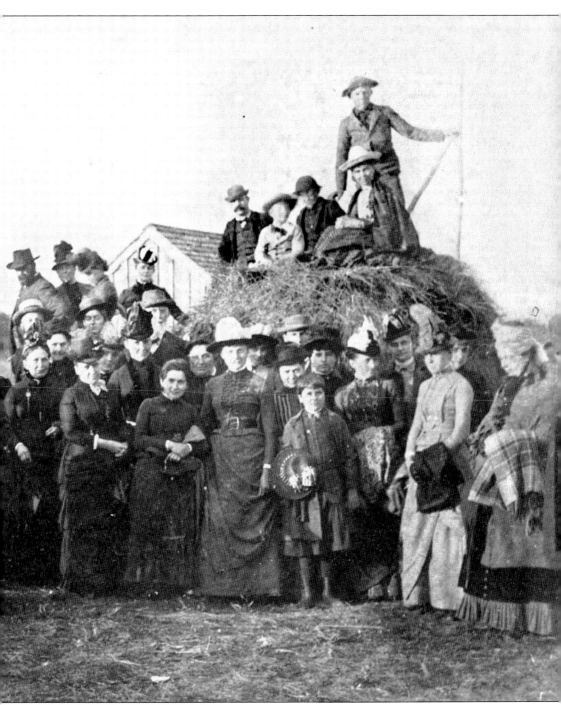

the extreme right, and Molly Darling is the small woman in the front row just to the left of the haystack. Lining the back row are students from the Hampton Institute. The featured trio in front is a local minstrel band equipped with a horse's jawbone (loose teeth made the music), accordion, and clapper sticks. (Courtesy Beverly Robinson.)

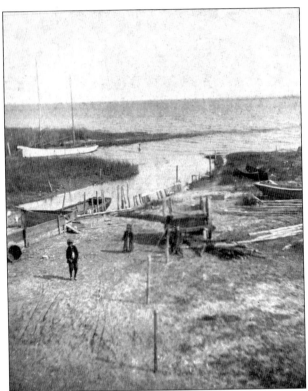

In 1874, 14-year-old John Cutler (J. C.) Robinson came to Hampton from Massachusetts. At the age of 19, he captained a menhaden fishing steamer and then set up a fish business in 1886 at the mouth of Robinson Creek. This is the fishery site before 1886, including several boats and an upside-down wagon. (Courtesy Beverly Robinson.)

Capt. J. C. Robinson built this house in 1888 for his bride, Ann Eliza Cock (Lila), whom he married in 1889. It stands today at 1600 Chesapeake Avenue. Lila is thought to be the woman on the porch step. In addition to the fish business, Captain Robinson helped organize the First National Bank of Hampton and started the first local telephone company (his number was 1). (Courtesy Dorothy Rouse-Bottom.)

This intriguing picture shows Robinson Creek and Capt. J. C. Robinson's early fishing enterprise, probably in the 1890s. The first J. C. Robinson house is at left rear, and the barn was there into the 1920s at least. The boy is not identified nor the purpose of the tank. Captain Robinson obtained oyster rights in the 1890s and added oyster packing to his venture at that time. (Courtesy Dorothy Rouse-Bottom.)

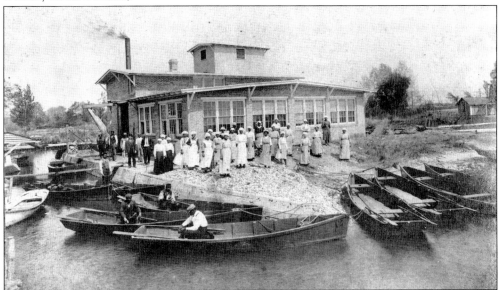

Captain Robinson continued to expand his seafood business, adding crab packing in 1910. He is the hatless man in the white shirt to the left of the pickers, with son Fred to the left of him. The boats are shallow-draft sailing skiffs common in the trade. The factory building, at 1610 Chesapeake Avenue, was a prominent landmark until its destruction in 1954. (Courtesy Beverly Robinson.)

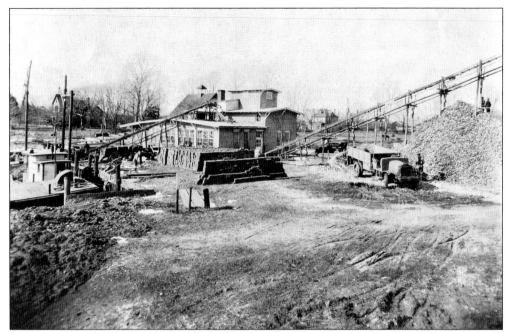

In 1914, Captain Robinson organized Clay Products Company. Bricks were made on the Chickahominy River and brought by boat to Wythe. This 1920s picture shows a boat in the slip, a man with a heavy load, the brick pile, and the oyster shell pile. In the background are the Robinson barn and first house (center left) and 1601 Chesapeake Avenue. (Courtesy Charles and Elizabeth Zimmerman.)

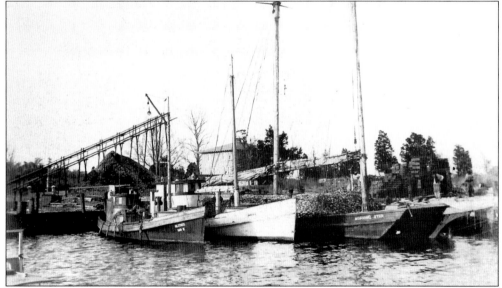

Captain Robinson's seafood and brick businesses depended heavily on small boats like these, shown at the slip beside the crab factory in the 1920s. The left two are classic Chesapeake buy boats, used to visit fishing boats and small docks, and the third is a multipurpose scow. The house was that of the captain's son Fred at 2200 Chesapeake Avenue. (Courtesy Charles and Elizabeth Zimmerman.)

Beginning in 1880, Collis P. Huntington brought the railroad and shipyard to Newport News. These ventures acted as a magnet, bringing investors, senior managers, and skilled workers to the Lower Peninsula. The need for housing for white- and blue-collar workers drove much of the subsequent growth in Wythe. This photograph shows the 1889 inauguration of a new dry dock with the monitor *Puritan* inside. (Courtesy Mariners' Museum.)

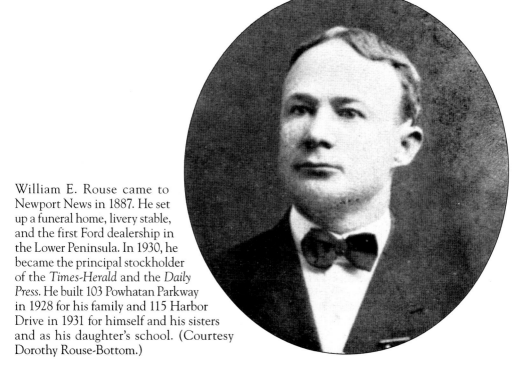

William E. Rouse came to Newport News in 1887. He set up a funeral home, livery stable, and the first Ford dealership in the Lower Peninsula. In 1930, he became the principal stockholder of the *Times-Herald* and the *Daily Press*. He built 103 Powhatan Parkway in 1928 for his family and 115 Harbor Drive in 1931 for himself and his sisters and as his daughter's school. (Courtesy Dorothy Rouse-Bottom.)

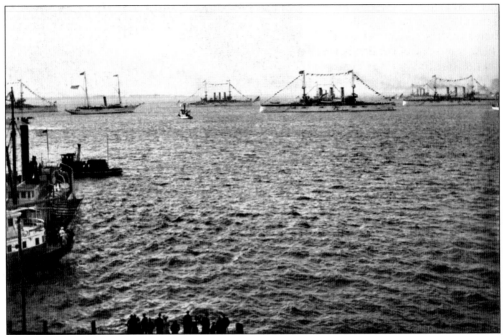

The 1907 Jamestown Exposition attracted worldwide attention to Hampton Roads. On December 16, Pres. Theodore Roosevelt dispatched a fleet of 16 new battleships, painted white with gold scrollwork, on an around-the-world voyage lasting 14 months. The Great White Fleet, as it was later called, is seen here on sailing day from Craney Island looking toward Wythe shores. (Courtesy Mariners' Museum.)

This view of two farmhouses on Raleigh Avenue was taken between 1894 and 1910. The trees in the distance are along Kecoughtan Road. These houses still stand today, at 303 and 311 Raleigh Avenue. Hannah Hickman McKinney remembers growing up at 303, the home of her grandparents Martin and Mary Byrnes, who bought the house in 1930. (Courtesy Hampton History Museum.)

Leonard Fulton Crockett was a general contractor who built his home at 350 La Salle Avenue in 1902. It was one of the first houses on the road connecting the Electric Avenue streetcar and the Boulevard. His daughter Jessie and son-in-law Charles Hopkins live there still. In this *c.* 1905 portrait are his wife, Esther Florence, daughter Pauline Esther, and son Paul Fulton. (Courtesy Jessie Crockett Hopkins.)

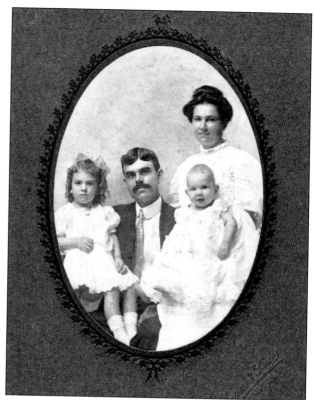

George Wythe School was built in 1909 to serve the burgeoning population of Wythe. It stood where the swimming pool at Claremont Avenue is today. This photograph is from 1912. Other local schools were Salters Creek (white), Salters Creek (black), and Bates (black), with West End Academy (the white high school) in Hampton proper. (Courtesy Jackie Potter.)

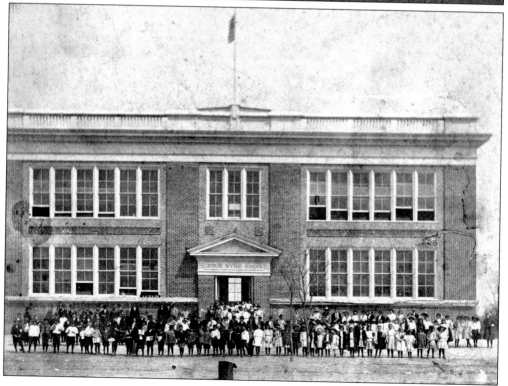

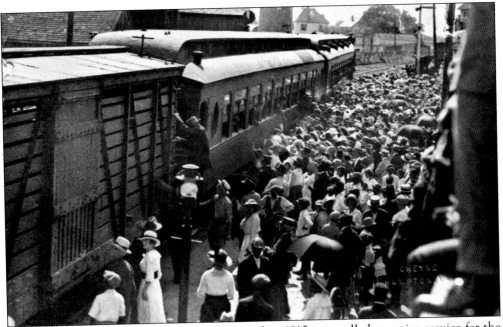

Battery D, 1st Virginia Field Artillery, organized in 1915, was called to active service for the Mexican Border War. Some 208 troops, shown here in June 1916, entrained for the border via Richmond and Texas. E. Sclater Montague recalled the poor state of initial equipage, going off to war in his tennis shoes. The 1st Virginia became the 111th Field Artillery Regiment in September 1917. (Courtesy Jack Hamilton.)

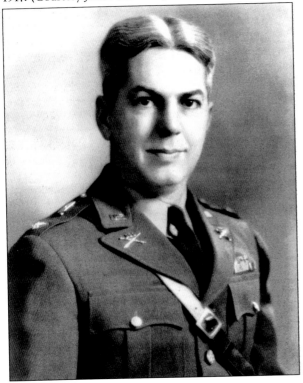

E. Sclater Montague was a prominent Hampton lawyer and a commander of Battery D, among other duties with the 111th Field Artillery Regiment. During World War II, at the time of this picture, he was the regimental commander. He built the Dutch colonial house at 3625 Chesapeake Avenue in 1938 and lived there until his death in 1980. The present National Guard armory was named for him. (Courtesy David Montague.)

Two

GROWTH OF A
STREETCAR SUBURB

At the beginning of the 20th century, the Lower Peninsula was poised between agrarian past and industrial future. The Electric (Victoria) Avenue streetcar in the 1890s tied the farms, orchards, and fisheries of Elizabeth City County with the Newport News shipyard and railroad colossus. La Salle Avenue grew up on the old Otley estate, providing a path to extend the streetcar in 1905 down to the new Boulevard (Chesapeake Avenue) and to the ferry dock at Manteo Avenue, supporting the exciting events of the 1907 Jamestown Exposition and connecting the big houses and golf course along the waterside. Capt. John C. Robinson's seafood industry was the anchor for a few homes among the orchards and farms near his creek as the streetcar was completed all the way along the Boulevard.

The growing industrial workforce, both white and blue collar, responded eagerly to the newly accessible real estate. On May 1, 1916, the Boulevard Development Company began selling lots in Indian River Park, making it one of the earliest planned communities in the country, with streetlights, sewers, and sidewalks. The opening of Langley Field north of Hampton added to the housing demand in 1917. In the 1920s and 1930s, the Armstrong properties began to sprout new bungalows and grand houses. Small stores along Kecoughtan Road served local needs, but by the 1930s, bigger businesses were showing up.

The storm of August 23, 1933, a nor'easter influenced by a hurricane, caused the worst natural destruction in Hampton Roads in nearly two centuries. In Wythe, it sent waves over the hedges on the Boulevard and wrecked the shoreline streetcar tracks beyond repair. Following this disaster, and in view of the growing popularity of the automobile, Wythe's attention turned landward to Kecoughtan Road and the bustle of new commerce.

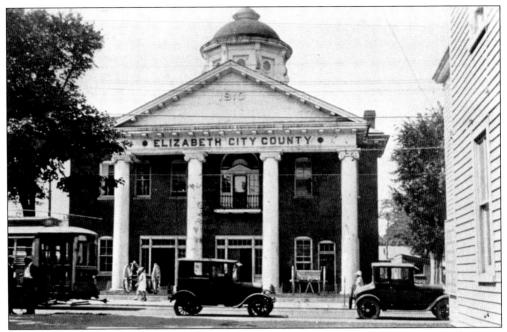

The turn of the century marked the transformation from an agricultural to a commercial society using advanced transportation links, especially streetcars. Elizabeth City County was still the government of Wythe, with its seat at Hampton. The present city courthouse on King's Way is the same one shown here *c.* 1915, built in 1876 and remodeled extensively in 1910. (Courtesy Shelby Liston.)

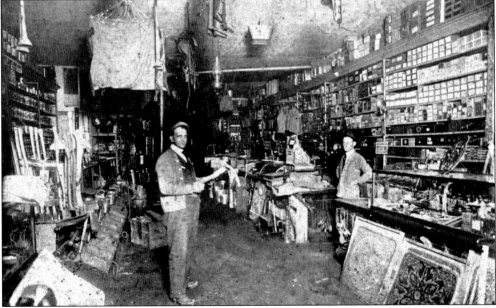

In 1895, William T. Patrick, age 18, established a hardware store on the county line at Queen Street and Back River Road. It served as a social center as well as supplier for both townspeople and new county residents moving near the new Electric Avenue (Victoria Boulevard) streetcar line. The business is still in the same building and family today. (Courtesy Cary Patrick Jr.)

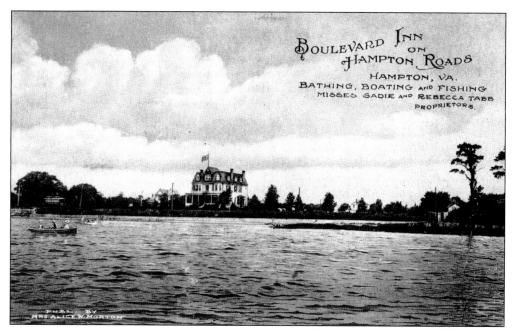

The Boulevard Inn, at the end of La Salle Avenue on the waterfront, was built as a Catholic boarding school in 1898. By 1904, it had become a resort hotel advertising boating at the mouth of Church Creek, as seen in this c. 1913 postcard. It later became a rooming house and then an apartment building before it was torn down in 1986. (Courtesy Jerry and Sandy Cobb.)

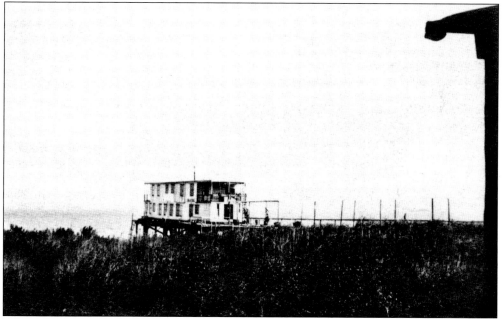

Albert T. LaVallette lived in this houseboat off the mouth of Church Creek for at least 20 years before the storm of 1933. Originally an Eastern Shore fisherman, Captain LaVallette farmed terrapins here and processed soft-shell crabs. His grandfather commanded the frigate USS *Constellation* from 1825 to 1828, and Albert had a World War I pilot boat off the Virginia Capes. (Courtesy Barbara Granger.)

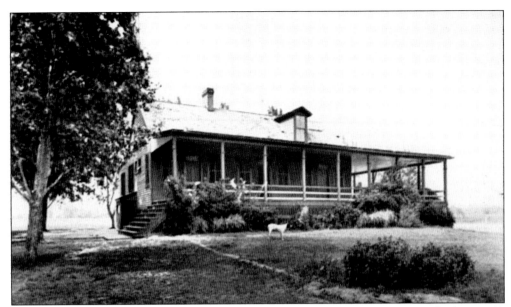

Hampton Roads Golf and Country Club was Virginia's first golf course. It was built in 1893 by local businessmen on land between La Salle and Hampton Roads Avenues. Pres. Woodrow Wilson played its nine holes twice, tying up his yacht at Manteo Avenue. The course closed in the mid-1920s, and the clubhouse became the residence seen in this 1930s photograph. (Courtesy Hampton History Museum/Cheyne Collection.)

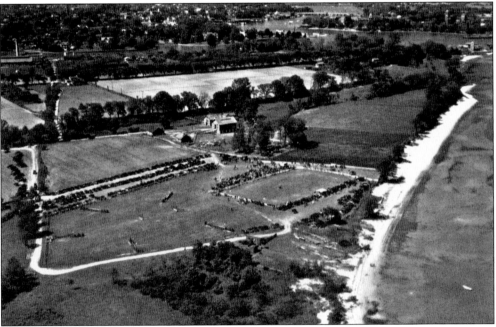

Harness racing was popular with both white and black residents of Wythe. In 1910, the Hampton Roads Driving Park was on Bay Avenue, probably near present-day St. Rose of Lima church. Another track, for blacks, was nearer Shell Road. A third track was opened later east of La Salle Avenue and is seen here during a horse show in the 1930s. (Courtesy Hampton History Museum/Cheyne Collection.)

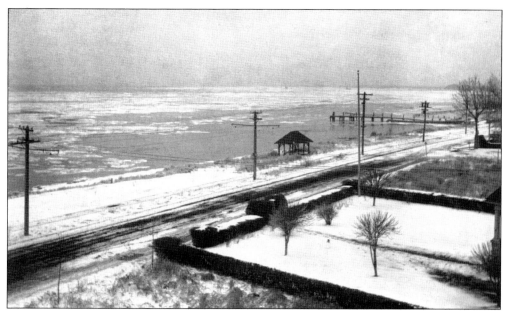

Between 1912 and 1914, a ferry line ran from Norfolk to the Manteo Avenue dock at far right of this photograph. This view to the southwest was taken from the Sniffen home at 3111 Chesapeake Avenue, probably after the ferry was moved to deeper water at the Newport News Small Boat Harbor. (Courtesy Mariners' Museum.)

BOULEVARD, LOOKING EAST FROM CHESAPEAKE FERRY ON HAMPTON ROADS, NEWPORT NEWS, VA.

This photograph was taken about 1913 from the Manteo Avenue dock, looking northeast toward La Salle Avenue. The Boulevard (Chesapeake Avenue) already had a number of mansions by the time the streetcar line was installed prior to the 1907 Jamestown Exposition. The Boulevard Inn and Captain LaVallette's houseboat are visible at the extreme right of the shoreline. (Courtesy Shelby Liston.)

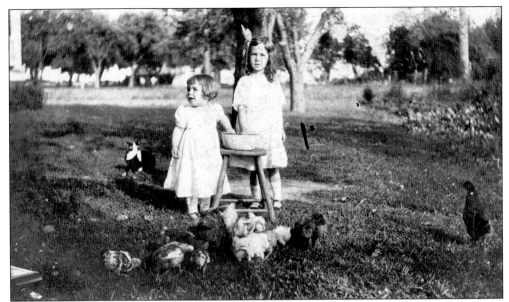

Charles J. Desper was an electrical draftsman who came to the peninsula in 1904 to work for the shipyard. He built a home along the Boulevard waterfront at 1325 Chesapeake Avenue, on grounds that included an apple orchard. In this 1917 photograph, Doris (left) and Virginia Desper are feeding the family's chickens in the backyard alongside the vegetable garden. (Courtesy Doris Desper Smith.)

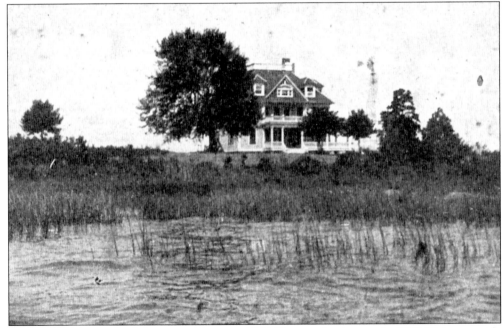

Capt. J. C. Robinson built his second home at 1500 Chesapeake Avenue in 1900. This waterside view, c. 1920, shows the wide expanse of marsh, now all gone. The large tree was a mulberry, which served as a tree house for neighborhood children (including the Despers) and a landmark for nearby oyster beds. The windmill powered a water pump from an underground stream. (Courtesy W. E. Rouse Library.)

A Message From *"Widewater"* on Hampton Roads Virginia.

An Ideal Place for Rest and Health.

DOES THE SALT SEA AIR MAKE YOU SLEEP WELL ? : :

ARE YOU FOND OF
BOATING
BATHING
FISHING
OR
GOLF ?

IF SO COME TO "WIDEWATER"

Elizabeth Franklin Landon was widowed in 1915 with four small boys to raise. Her response was to open her home at 3209 Chesapeake Avenue as a resort hotel featuring water views and sports, "Christian surroundings," and seafood caught out front. In 1930, she divided it into five apartments, which were returned to a single-family dwelling by her descendants in the 1970s. (Courtesy Bill Boyer.)

Riverview, north of Indian River Park, was a working-class neighborhood developed by Warwick Iron Works. Will, Edward, and Don Haldeman are shown from left to right c. 1920 at 507 Darnaby Avenue. All three apprenticed at the Newport News shipyard. After World War II, Eddie took up successfully nearly every kind of marine enterprise, including a marine railway, chandlery, and tugboats. (Courtesy Carolyn Haldeman Hawkins.)

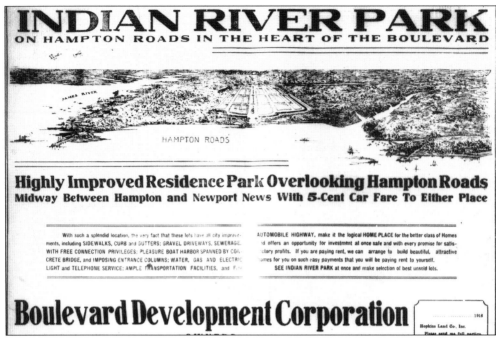

On May 1, 1916, lots went on sale in Indian River Park, one of the first planned communities in the country. This June 1, 1916, newspaper advertisement touted its location midway between Hampton and Newport News, albeit altering the proportions just a little. Lot prices were $450 to $1,250, and plans included electricity, sewers, streetlights, sidewalks, and a pleasure boat harbor. (Courtesy *Daily Press* Archives.)

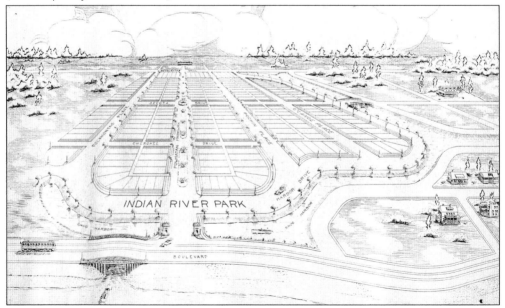

This promotional poster was run as part of the 1916 advertising campaign for Indian River Park. It shows Harbor Drive complete along the eastern waterway and a bridge at Secota Drive on the right, neither of which ever happened. Note the streetcars on Chesapeake and Electric Avenues and the golf clubhouse on the extreme right. (Courtesy Lewis Whitehouse.)

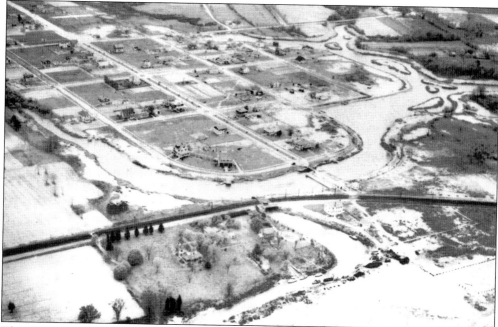

This 1919 aerial photograph, taken by an Army Air Corps pilot from Langley, shows the development in Indian River Park. Note the river's long estuary running under Chesapeake Avenue, past the Hewinses' property on the west bank, boat docks, and a sandy swimming beach. New ornamental planting can also be seen down the middle of Powhatan Parkway. (Courtesy Lewis Whitehouse.)

Attorney Allan Jones Sr. built homes at both 109 and 113 Harbor Drive. Jones was instrumental in the establishment of Indian River Park and among the first to build there. One of the ornamental streetlights can be seen in front of 113. The boat is a Poquoson three-log canoe. This photograph was taken near the Powhatan Parkway bridge, probably in the early 1930s. (Courtesy Lewis Whitehouse.)

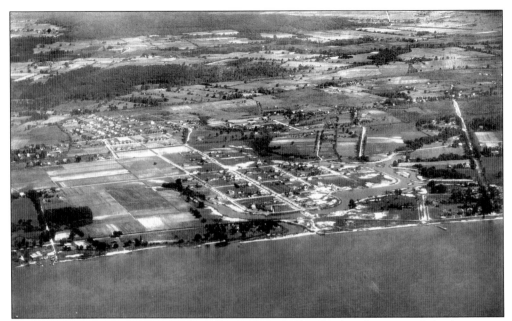

In this 1924 view, Indian River Park stands out from the farmland to the west and the Armstrong property to the east. Early residential development can be seen on the land that had recently been part of the golf course. Capt. J. C. Robinson's dock, seafood plant, and brick barges are visible on the extreme lower left. Riverview can also be seen in the left rear along Electric Avenue. (Courtesy W. E. Rouse Library.)

Indian River Park lived up to its promise of a harbor for small pleasure boats. Sixteen-year-old Paul Webb came to Hampton with his banker father, James, and aunt Effie in 1927. For several years, they lived at 501 Harbor Drive. Paul is shown at that house's dock in the early 1930s. Notice that most of the property across the river was still not developed. (Courtesy Maureen Webb.)

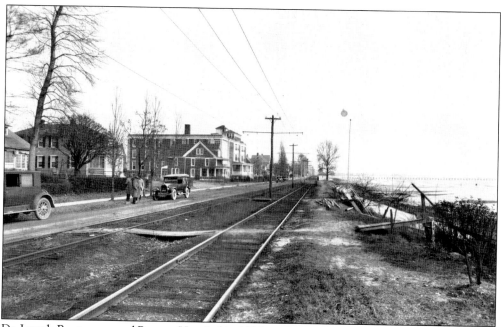

Dr. Joseph Buxton opened Buxton Hospital in 1906 on the Boulevard at Cypress Avenue, with 15 beds growing to 100 by 1930. A nursing school was added in 1907. In that year, a week's private hospital room cost $12. In 1927, its address changed to Buxton Avenue, Newport News. In 1953, it became Mary Immaculate Hospital and was reconstructed as Riverside Rehabilitation Center in 1980. (Courtesy W. E. Rouse Library.)

On June 19, 1916, a section of Wythe bounded by the Boulevard, Salters Creek, Shell Road, and Pear Avenue was incorporated as Kecoughtan, Virginia, population 1,009. The town hall was above the fire engine house at 109 Poplar Avenue. On January 1, 1927, Newport News annexed the town as a result of residents' petition. The boundary of Elizabeth City County became the middle of Pear Avenue. (Courtesy Carol King.)

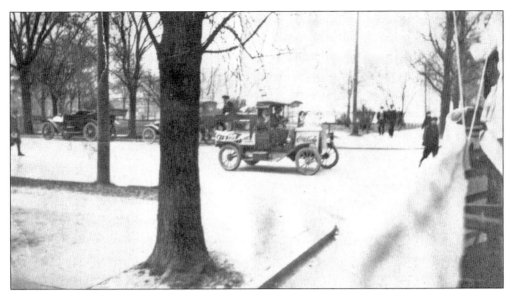

Raymond Brown (nicknamed "Coca Cola" Brown) bought the original, exclusive Newport News Coca-Cola franchise on March 1, 1914, for $4,500. He settled his family at 1221 Chesapeake Avenue in the 1930s. He also invented a bottle opener, which was intended to make bottled drinks easier for housewives to serve. This *c.* 1915 photograph shows a delivery truck near the Newport News Post Office. (Courtesy John H. Brown.)

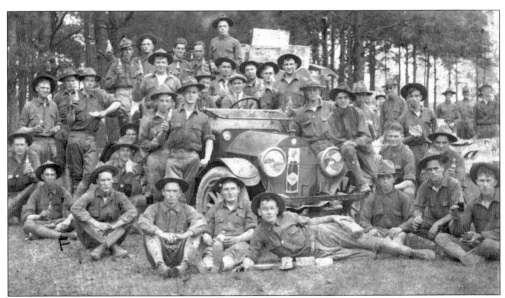

World War I had tremendous impact on the Lower Peninsula. It was a major embarkation and debarkation site, involving large troop camps and transportation links to the ports. Ray Brown is shown here *c.* 1917 with troops, possibly at Camp Eustis. Note the Coca-Cola bottles in their hands and the logo on the front of Ray's car. (Courtesy John H. Brown.)

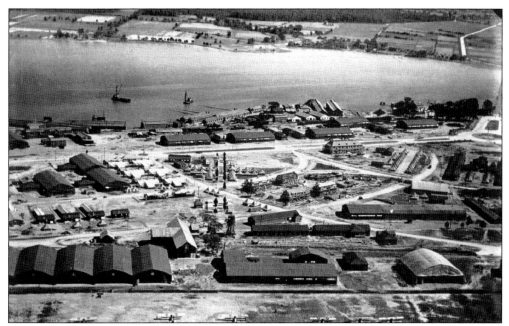

Langley Field came about as a joint venture of the U.S. Army Signal Corps and the National Advisory Committee for Aeronautics (NACA), who chose it in December 1916 because of climate, security, deepwater access, local military and industrial support, and preparation as a total real-estate package by local business leaders. This photograph was taken between 1918 and 1920. (Courtesy Headquarters Air Combat Command.)

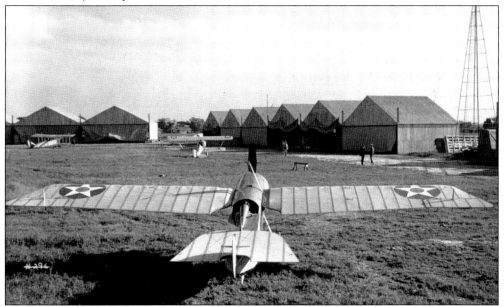

Langley Field got into operation in a hurry. Fabric hangars and grass parking areas were typical of World War I aviation, but Langley had a special role in evaluating candidates for U.S. Army current and future needs. This Albree wire-frame monoplane with rotary engine was judged hopelessly inadequate and never made it to production in the United States (Courtesy Headquarters Air Combat Command.)

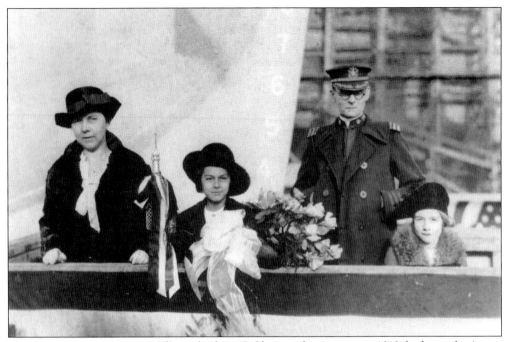

U.S. Navy captain George Mallison built 1117 Chesapeake Avenue in 1910 for his wife, Anne, and daughter, Mary Anne. In this photograph, Mary Anne is about to christen the U.S. Navy oiler *Sapelo* on December 24, 1919. The *Sapelo* later saw heroic service on convoy duty in World War II. The child at bottom right is probably Aletta Muse, from 1203 Blair Avenue. (Courtesy Ray Hooker.)

Ferrante Ferrari was an Italian blacksmith who came to this country about 1917, changed his name to Fred, and went to work for the Warwick Machine Company at the World War I embarkation center. He bought a house at 1203 Electric Avenue (Victoria Boulevard) in 1920 and set up a smithy there from which he produced much of the ironwork for the first Colonial Williamsburg restoration. (Courtesy Fred Ferrari Jr.)

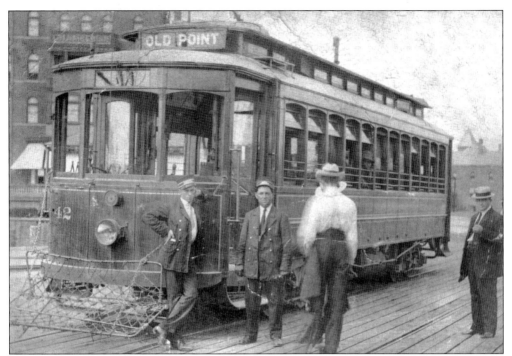

William Weston (left) was a motorman on the Electric Avenue (Victoria Boulevard) line. His daughter's family settled at 503 Harbor Drive in Wythe. This 1920s photograph shows passengers bound for Phoebus, Hampton, Wythe, or Newport News as they boarded the streetcar near the Old Point dock at Fort Monroe. (Courtesy Virginia LaNeave.)

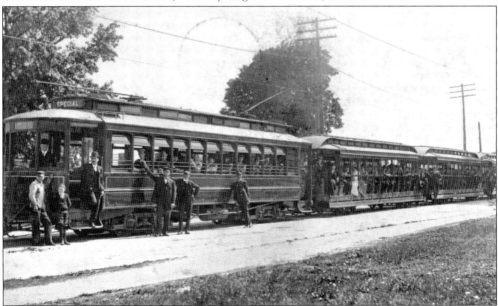

Special holiday trolleys were arranged for groups traveling from Newport News to Buckroe Beach. Boulevard residents remember seeing the picnic baskets and hearing gay sounds from the party-makers passing by. The trains in 1927 were redecorated to a Parisian color scheme of burnt orange with cream trimmings. (Courtesy Virginia LaNeave.)

The old Celey lands from Salters Creek to Hollywood Avenue were laid out in streets by several land companies c. 1891. Development began in earnest with the local World War I industrial buildup. In this c. 1920 view of Blair Avenue, the houses with backs on the right are 1205 and 1201 Chesapeake Avenue, and the one straight ahead was later rebuilt by Coca Cola Brown. (Courtesy Nancy Cox.)

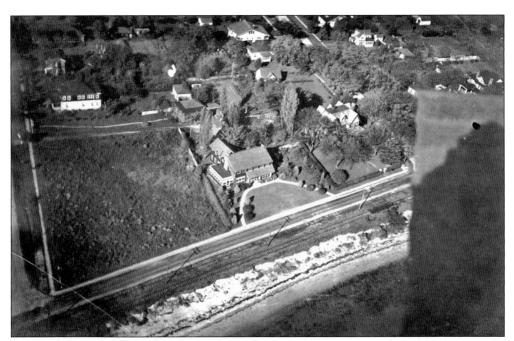

In 1920 or 1921, bank president and Virginia delegate Nelson Groome built 3417 Chesapeake Avenue. One of three business leaders who assembled the real-estate package for Langley Field, Groome died of a heart attack at age 53 in 1922. In the early 1930s, his widow rented the house to 10 engineers from Langley, who dubbed it the "X-Club." This aerial view is c. 1934. (Courtesy Warren Wetmore.)

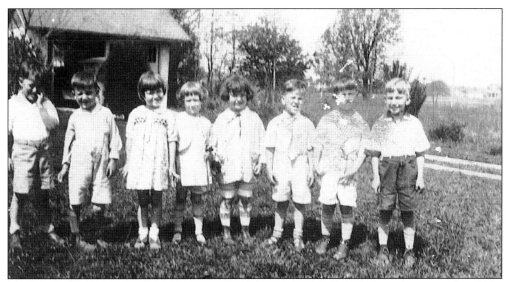

Wythe was home to a number of private schools located in teachers' homes starting in the 1920s. As late as 1971, Miss Porter's School was holding classes at 3427 Chesapeake Avenue. This 1920s photograph, looking toward Kecoughtan Road, features a kindergarten taught by Frances Albee at 73 Cherokee Road. Mrs. Albee's grandson lives there today and is restoring the house. (Courtesy Ron and Carrie Quinn.)

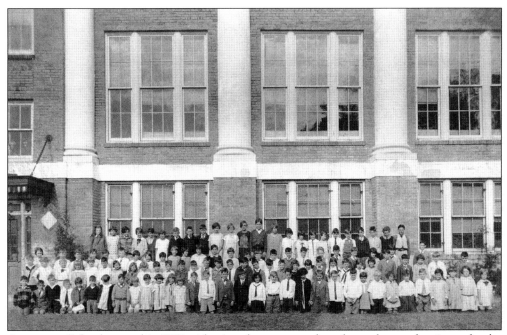

Armstrong School opened in 1922 with nine classrooms and teachers, plus a cafeteria run by the parents' organization. It was built on land donated by the Armstrong Land and Improvement Company to accommodate the growing population of the eastern end of Wythe. In this c. 1924 photograph, Jessie Crockett is ninth from the left in the third row. (Courtesy Jessie Crockett Hopkins.)

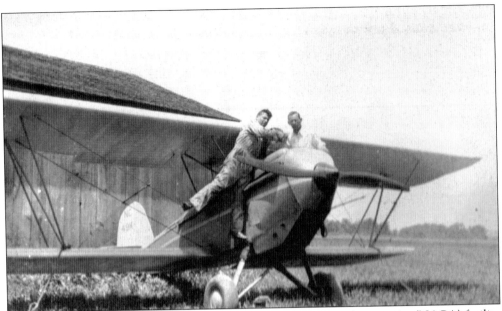

Ray Hooker (left) came to the National Advisory Committee on Aeronautics (NACA) facility at Langley in 1930. He and fellow engineer Al Young taught themselves to fly using a home-designed glider towed by a truck, then built this aircraft around a World War I engine. In 1959, he set up manned space flight stations around the world for the Mercury Project. (Courtesy Ray Hooker.)

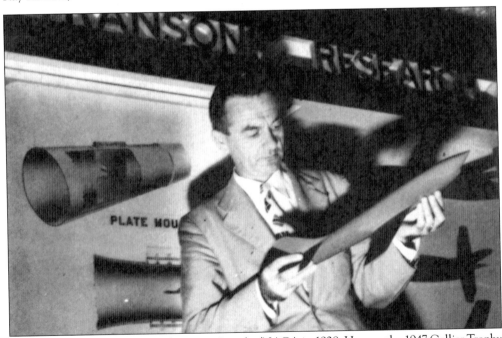

Aeronautical engineer John Stack came to Langley/NACA in 1928. He won the 1947 Collier Trophy for the first supersonic flight, along with aircraft manufacturer Lawrence Bell and pilot Chuck Yeager. John Stack won the Collier again in 1951 for the variable transonic wind tunnel ventilated throat. He and his wife, Helen, lived at 112 Hampton Roads Avenue. (Courtesy NASA.)

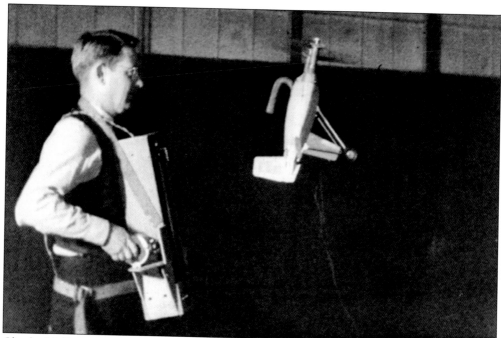

Charles H. Zimmerman, aeronautical engineer, came to NACA in the early 1930s. He married Beatrice Fitz, a schoolteacher from Maine, and they lived initially in the third-floor apartment of Capt. J. C. Robinson's house at 1500 Chesapeake Avenue. After some other job moves, they returned in 1948 to settle down at 95 Alleghany Avenue. (Courtesy Charles H. Zimmerman Jr.)

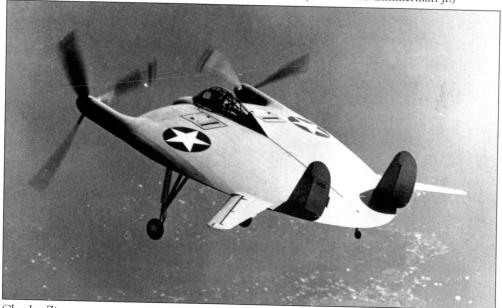

Charles Zimmerman won a NACA design competition in 1933 with a circular-wing aircraft concept. When NACA did not pursue the idea, he built models on his own time, going on to develop the V-173 prototype with Chance Vought Aviation. Starting in 1942, its many test flights featured both high and very low speeds as well as short take-offs and landings. (Courtesy Charles H. Zimmerman Jr.)

The storm of August 1933 sent water levels over the hedges on Chesapeake Avenue. In this scene from a rare home movie outside the Benson and Williamson homes at 3009 and 3011 Chesapeake Avenue, residents are celebrating Lillian Williamson (right), who had just swum Indian River to get milk for her visiting two-year-old niece. That niece lives in the family home today. (Courtesy Jane Abbott.)

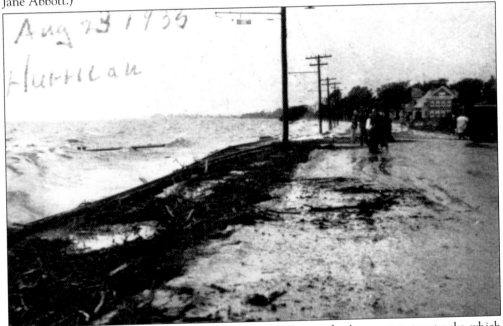

The storm's greatest damage in Olde Wythe was to the Chesapeake Avenue streetcar tracks, which were beyond salvage. This photograph was taken on the 3400 block. Buses substituted for that streetcar and, later on, for the trolley on Electric Avenue as well. Better transportation and the World War II military buildup would lead to residential and business growth along Kecoughtan Road. (Courtesy Ray Hooker.)

Three

THE BOOM YEARS

The 1930s through the 1960s brought much change to the area, defining it as the Wythe many of us remember. Supporting infrastructure such as improved shopping centers, restaurants, modernization of roads and drainage, expanded mass transit options, and improved fire department and rescue squad services were developed to serve an ever-growing population, which rivaled that of Hampton. Even as Elizabeth City County and the political entity of the Wythe Magisterial District dissolved upon consolidation with the City of Hampton on July 1, 1952, the allure of and pride in Wythe remained intact, as happened also in similar county communities such as Fox Hill and Buckroe Beach. Today, 54 years after the consolidation, people still refer to the southwest corner of the city as "Wythe."

The stretch along Kecoughtan Road became home to many unique establishments, such as the Brown Derby Restaurant at 2505, which had a large, three-dimensional derby fastened on the roof, and Chicken Delight restaurant at 1604, which provided home delivery with a Renault Dauphine complete with a large chicken on its roof. While downtown Newport News and Hampton featured Washington Avenue and Queen Street as business districts in a more traditional sense, Kecoughtan Road was just as memorable to baby boomer children and their parents and still somewhat survives to this day after the more traditional downtown venues have vanished.

100 CITIZENS OF WYTHE DISTRICT ENDORSE

J. G. CRENSHAW

for re-election as

COUNTY SUPERVISOR

From Wythe District

Subject to Democratic Primary

AUGUST 1, 1939

James Guy Crenshaw Sr. lived at 43 Hollywood Avenue. A bookkeeper by trade, he was also business manager of the Peninsula Shipbuilders Association of Newport News Shipbuilding, county supervisor for the Wythe Magisterial District, member of the Wythe District Fire Department, president of the Firemen's Association of Tidewater Virginia, and first mayor of the consolidated City of Hampton in 1952. (Courtesy Tom Norris.)

Hardy W. Cash, shown here in 1949, lived with his mother and sisters at 314 Pear Avenue from 1938 to 1955. In 1947, he went to work for Elizabeth City County as an administrative assistant. On July 1, 1952, he became the first Hampton city purchasing agent, then zoning administrator and director, and finally the city ombudsman in 1996. (Courtesy Hardy Cash.)

Hunter Booker Andrews served in the navy in World War II and then became an attorney. He was a Virginia senator from 1964 to 1996, including 15 years as senate majority leader, making lasting improvements in education and civil rights. He and his wife, Cynthia, lived in Wythe from 1951 to 1963. This 1957 photograph is of daughter Bentley, dog Schlitz, and Hunter at 3612 Kenmore Avenue. (Courtesy Cynthia Andrews.)

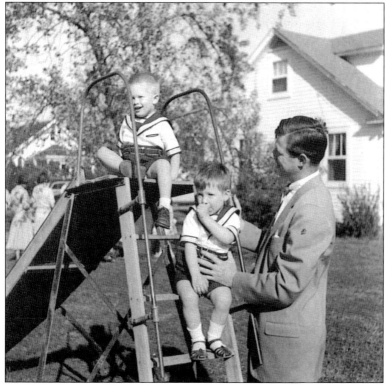

The Colonna family lived at 47 Alleghany Avenue from the 1930s. George B. Colonna was president of Dixie Hospital and a district Rotary leader in the 1960s, and his children were very popular at local playgrounds. Seen here from left to right in 1954 are Booker Andrews, George B. Colonna III, and local businessman George Jr. at the Andrews home at 3612 Kenmore Avenue. (Courtesy Cynthia Andrews.)

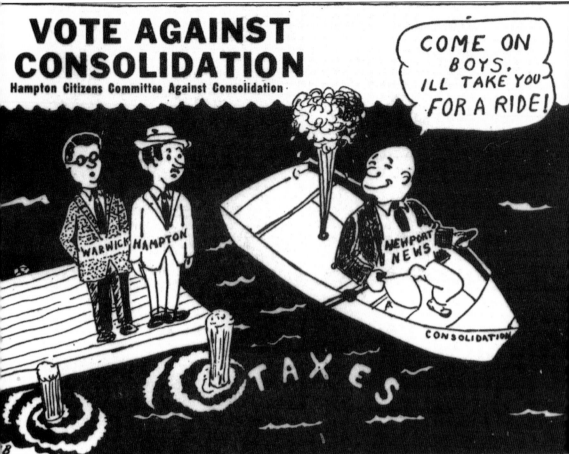

Consolidation was a hotly contested topic in the 1950s, and it still emerges for discussion today. The roots of this issue began back in the early part of the century, when the Town of Kecoughtan emerged and then dissolved. The area was claimed by both Newport News and Elizabeth City County, as the county line traversed west to east during the 1920s and 1930s. This political cartoon from 1956 is indicative of the issue. Only a few years after the Elizabeth City County/Hampton/Phoebus consolidation and the conversion of Warwick County into the City of Warwick in 1952, further upheaval was imminent with the proposed consolidation of the Tri-Cities (Hampton/Newport News/Warwick) into one large city. Warwick consolidated with Newport News on July 1, 1958, after only six years as a city, while Hampton held on to its independence. (Courtesy *Daily Press* Archives.)

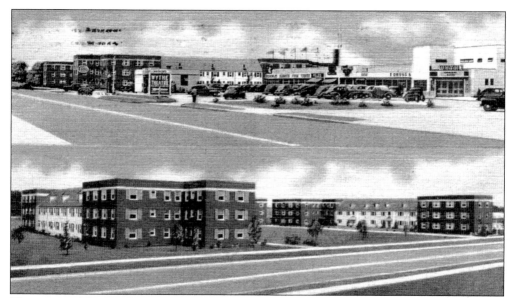

This postcard depicts the new Wythe Shopping Center and Kecoughtan Court Apartments on Kecoughtan Road. The shopping center was a major asset to the Wythe area. The shopping center included a grocery store and movie theater. The Kecoughtan Court Apartments became home to many young couples just moving to the area. (Courtesy Tom Norris.)

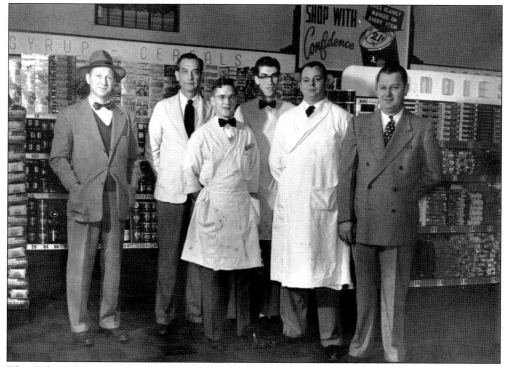

The Colonial Store in the Wythe Shopping Center was one of the first chain grocery stores in Wythe. Management and staff proudly show off their store in this 1953 picture. A&P built a competing grocery store at Kecoughtan and Chesterfield Roads. Wythe residents became loyal shoppers of both stores. (Courtesy Hampton History Museum/Cheyne Collection.)

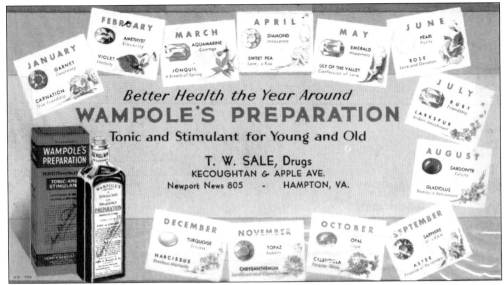

Thomas W. Sale Sr. opened a drug store with a soda fountain at 819 Kecoughtan Road in 1938. He often ran the store single-handedly more than 14 hours a day, 6 days a week. He died in 1945, and his wife, Mildred, kept it going until their son, Thomas Jr., came home from World War II. It later became Clodfelter's Pharmacy. (Courtesy Thomas W. Sale Jr.)

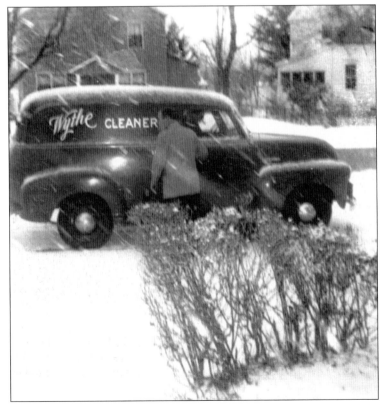

Harking back to a time when laundries picked up and delivered, the Linkous family of 109 Greenbriar Avenue is receiving a delivery from Wythe Cleaners, which was located at the corner of Powhatan Parkway and Kecoughtan Road. The truck was a common sight throughout the streets of Wythe during the 1940s and 1950s. (Courtesy Harold Linkous.)

The Bank of Hampton Roads opened this branch office on the corner of Kecoughtan Road and Pocahontas Place in 1942. It featured one of the first drive-up teller windows in the area. The Wythe Theater, which opened on October 6, 1939, can be seen in the left of the picture. (Courtesy Maureen Webb.)

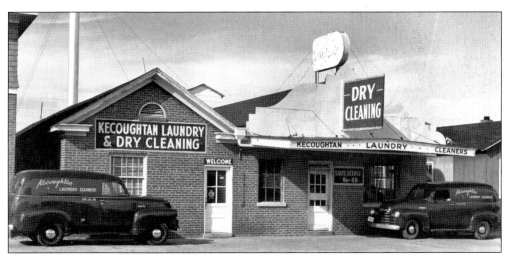

Kecoughtan Laundry and Dry Cleaners has been a mainstay on Kecoughtan Road since the early 1940s. In 1948, the family of Ken Balzer, the current owner, bought the business and moved from New York State. The land on which the business was built was once a dairy farm. This photograph, taken in the 1950s, shows that little has changed, as it looks much the same today. (Courtesy Ken Balzer.)

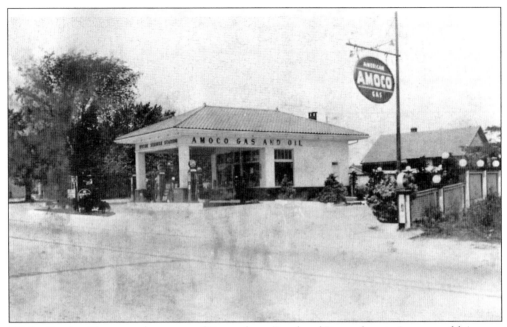

Wythe Service Center, at the corner of Kecoughtan Road and Pennsylvania Avenue, sold Amoco gasoline products for many years. This 1938 photograph depicts the classic Baltimore style of construction, named for its city of origin. (Courtesy Tom Norris.)

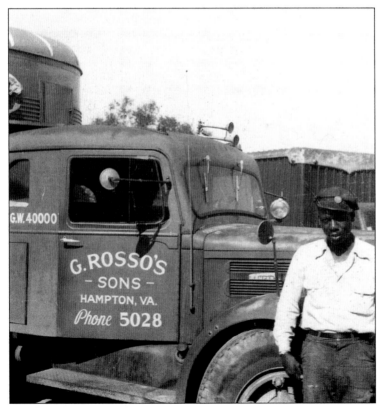

G. Rosso's Sons sold wholesale produce at 2619 Kecoughtan Road for several years. This photograph, from the late 1940s, shows one of their over-the-road tractor-trailer rigs along with the driver, Archie. The company provided fresh produce to many of the stores and restaurants in the local area. (Courtesy John Rosso.)

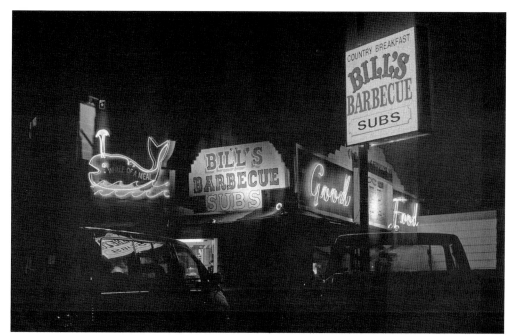

Bill's Barbecue was a local icon. At the corner of Kecoughtan Road and Pennsylvania Avenue in the heart of Wythe, it was a favorite eatery of many. The close proximity to George Wythe Junior High, coupled with great food, made it a natural teenage hangout. Opening in the 1930s, it was one of the first restaurants featuring curb service. (Courtesy Elizabeth Lankes.)

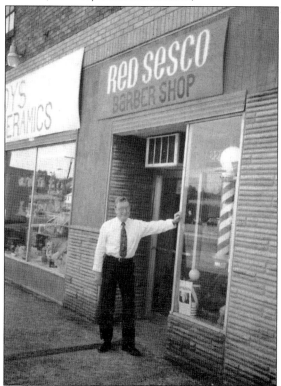

Red Sesco, in front of his barbershop at 2202 Kecoughtan Road, served the needs of many Wythe men for several decades. He is still in business today at his shop on Armistead Avenue in the Tidemill section of Hampton. Some longtime patrons from Wythe still make the trip to Red's to have their "ears lowered." (Courtesy Red Sesco.)

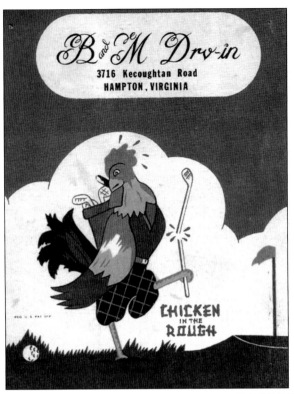

Another restaurant of the area was the B&M Drive-In, near the intersection of Kecoughtan Road and La Salle Avenue. A specialty of the B&M was Chicken in the Rough—an early fast-food franchise started during the Depression. Chicken in the Rough was simply fried chicken served in a basket and eaten with your fingers. (Courtesy Tommy Coleman.)

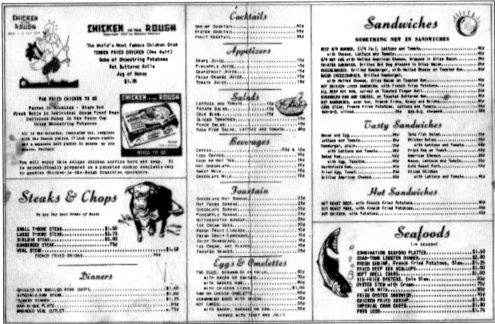

You can see by this menu from the 1950s that the B&M Drive-In not only had Chicken in the Rough but also offered everything from breakfast to a complete steak or seafood meal, plus sandwiches and appetizers. It was a very popular place to eat for both the young and old. (Courtesy Tommy Coleman.)

There have been a number of eateries where the Oasis Restaurant now sits at 3508 Kecoughtan Road. This montage shows the 1948 Annual Smoker at Terry's Supper Club (a private men's club), as well as an early frequent-patron meal card in 5¢ increments. The Oasis is still a very popular family restaurant in Olde Wythe. (Courtesy Nick Sorokos.)

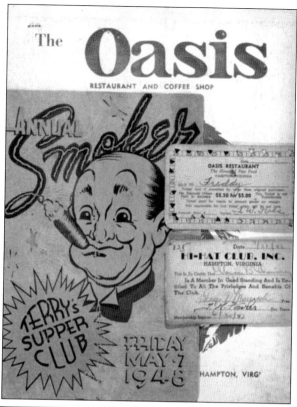

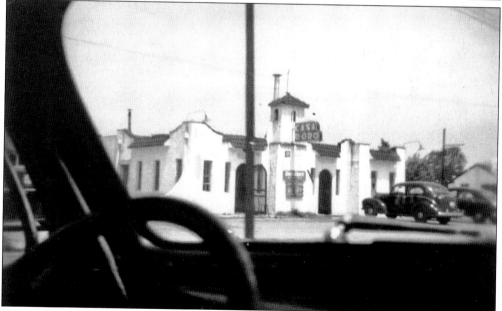

If you were cruising eastbound along Kecoughtan Road in the early 1940s looking for some good food, the Casa D'Oro at 1803 Kecoughtan Road might seem very inviting. Looking through the windshield of a 1930s automobile, one can almost hear the sounds of Benny Goodman playing on the radio. (Courtesy Jack Boerner.)

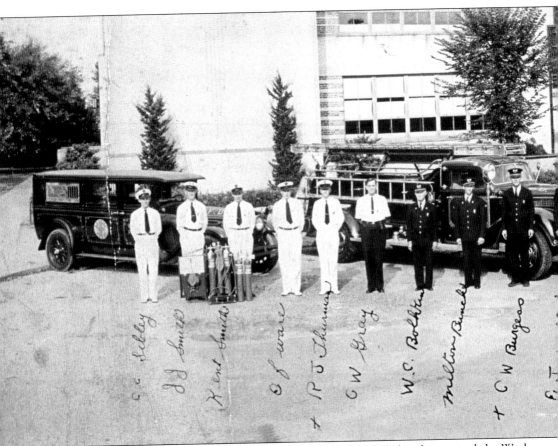

In 1909, a group of residents decided that a fire company was needed and organized the Wythe Fire Company. A fire station was erected on the west side of Kecoughtan Road and Claremont Avenue. In 1923, the Wythe Company and the Riverview Company (another fire company located within the Wythe district) merged under the name of the Wythe District Fire Department, with

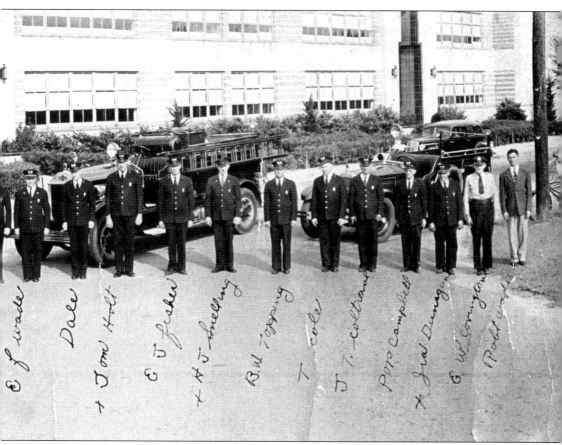

E. J. Wade, Dale, T. Jon Holt, E. J. Fisher, H. J. Snelling, B. W. Topping, T. Cole, J. T. Coltrane, Pero Campbell, Fred Dunagan, E. W. Covington, Robt Wright

the combined headquarters being the station on Claremont Avenue and Kecoughtan Road. In 1932, the department outgrew its quarters, so the old Hopper-Hardy Garage, adjacent to the George Wythe School, was purchased and remodeled. Pictured is a group photograph of the fire company from the early 1940s. (Courtesy Wythe Fire Station.)

In the 1930s, William Pettitt, a Wythe volunteer fireman, attended a convention in Suffolk, driving a 1929 Packard he had rebuilt. This photograph shows, from left to right, Mrs. Billy Wynne, three unidentified, Billy Wynne (in dark cap), unidentified, Johnny Linkous, Richard Miller, Jackie Pettitt, Billy Pettitt Jr., and William Pettitt. William later donated the Packard to the fire department, which refitted it as the first ambulance. (Courtesy William Pettitt Jr.)

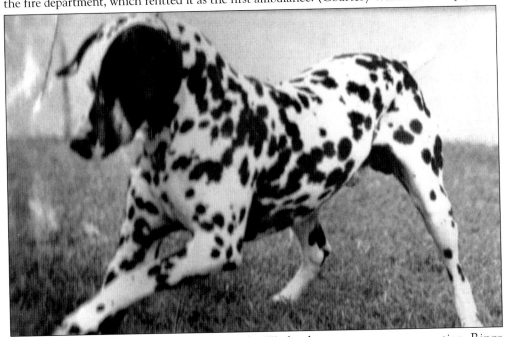

Every fire department needs a mascot, and the Wythe department was no exception. Ringo came to the department in 1949 as a six-month-old pup. Ringo never missed a fire. He fearlessly headed into the blaze, barking and searching for folks. He was even said to put out fires with his paws. Around 5:00 p.m. on most days, he went across the street for a milk shake at the High's Ice Cream Store. (Courtesy Wythe Fire Company.)

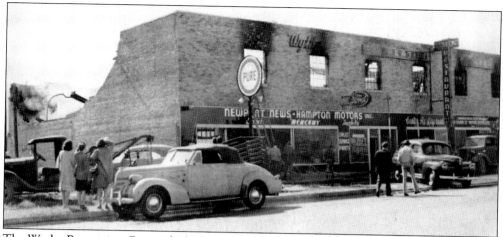

The Wythe Recreation Center duckpin bowling alley, on the second floor of 2200 Kecoughtan Road, suffered a devastating fire in the mid-1940s. In the picture are Newport News-Hampton Motors, the branch office of the Division of Motor Vehicles, and the Center Restaurant. Wythe Recreation Center reopened after repairs, though the second floor was later demolished. (Courtesy Wythe Fire Station.)

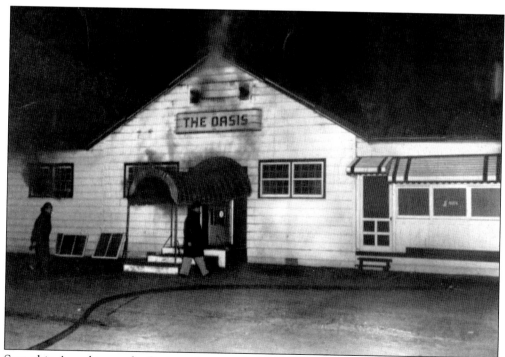

Something's cooking at the Oasis; unfortunately this time it *was* the Oasis. A major fire destroyed part of the building, but the quick response of the Wythe Fire Department prevented more damage. The building was able to be repaired and the restaurant was reopened, to the delight of Wythe residents. (Courtesy Wythe Fire Station.)

Anne Wythe Hall, at Bay Avenue and Lombard Street, was a World War II temporary federal housing complex for female government workers. The Catholic Church owned the land and bought several of the buildings after the war to start the new parish of St. Rose of Lima. This building became the parish's first school, opened in 1949. (Courtesy Mary Caroline Boerner.)

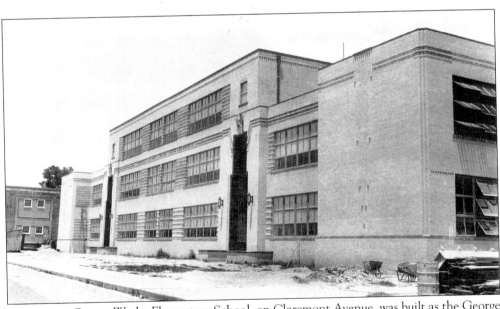

The current George Wythe Elementary School, on Claremont Avenue, was built as the George Wythe Junior High School. Twin entrances are ornately decorated, each with an owl (the school mascot) and the motto, "Enter To Learn, Leave To Serve." This c. 1937 photograph shows both it and the first Wythe School. Subsequently the old building was torn down, and the junior high moved to new quarters on Catalpa Avenue. (Courtesy Library of Virginia.)

This picture was taken looking east along Second Street (now Kenmore Drive) at the intersection of Shenandoah Road in 1938. It was a follow-up to an automobile accident involving Ralph James. Note the overall newness of the area: the house to the right was only two years old and the trees had yet to mature. (Courtesy Hampton History Museum/Cheyne Collection.)

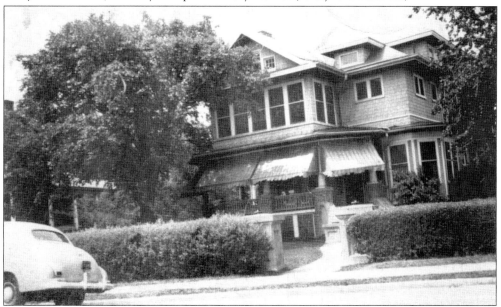

During World War II, Sadie Garrett ran a boarding house at 3515 Chesapeake Avenue, largely for young engineers at Langley/NACA. She was among many who expanded the temporary housing stock by opening their homes to boarders. The house was a magnet for local young people, who enjoyed the company and the nearby fishing pier. (Courtesy Selma West Moore.)

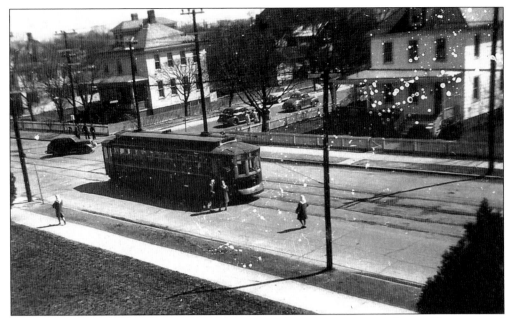

Trolley cars, operated by the Virginia Public Service Company, were prevalent in Hampton and Wythe. This picture, taken from Hampton High School in the early 1940s, shows a trolley car making a stop along the main line, which ran from Newport News to Hampton, Phoebus, and Buckroe Beach. This intersection is Victoria Avenue (now Boulevard) and Jackson Street (now Kecoughtan Road) at the Hampton/Elizabeth City County line. (Courtesy Jack Boerner.)

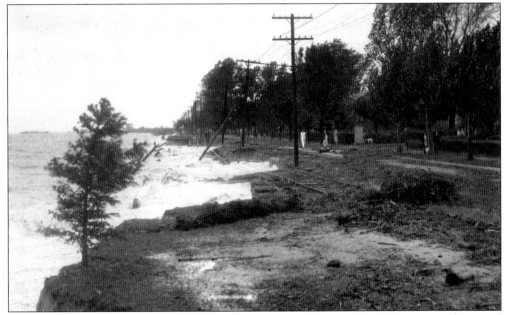

A major blow to trolley service came when the storm of August 23, 1933, came onshore and destroyed the Boulevard (now Chesapeake Avenue) trolley line. This line connected the lower sections of Newport News and Hampton with the Hampton main line by way of La Salle Avenue. The Boulevard line was never rebuilt; instead, bus service took its place. (Courtesy Barbara Granger.)

Trolleys had several shortcomings. While pollution-free and environmentally friendly, they were bound by the location of track and overhead electric wires and were sometimes prone to accidents. This 1929 photograph shows the results of one such accident. (Courtesy Hampton History Museum/ Cheyne Collection.)

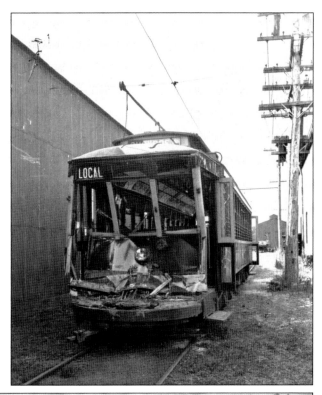

TROUBLE REPORT
FORM M-101

CAR BUS NO. 256391

DATE 3/2 19 43

REPORT ALL LOST TIME, NATURE OF TROUBLE, AND LOCATION

TIME OFF 12:45 TIME ON 12 15 LOST TIME 30

A TROUBLE REPORT MUST BE MADE REGARDLESS OF CONDITION OF CAR OR BUS

GARDNER F

VICTORIA + HIGHLAND
JUMPED TRACK

BY _____ K

SIGNATURE OF OPERATOR

This March 2, 1943, trouble report documents a trolley jumping the track at Victoria Avenue and Highland Avenue, near the carbarn that housed the streetcars (now the Hampton Rapid Transit bus garage). On January 14, 1946, another trouble report concerned a trolley jumping the track on Queen Street at Dixie Hospital. After this incident, trolley service was halted. (Courtesy C. E. and Charlotte Pratt Johnson.)

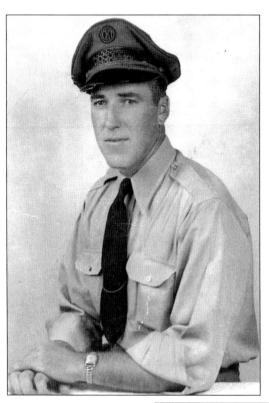

Clyde Pratt, shown here in his official uniform, was a trolley operator and bus driver for Virginia Public Service Company (VPSC) and then Citizens Rapid Transit (CRT) from 1941 through 1956. He lived on Algonquin Road and Hampton Roads Avenue. During World War II (as in World War I), transportation service was essential to the functioning of the Hampton Roads U.S. Army Port of Embarkation. (Courtesy Janice Pratt McGrew.)

In May 1944, VPSC merged with Virginia Electric and Power Company (VEPCO), which sold the streetcars and facilities to CRT on April 1, 1945. During the transition, pay stubs reflected both entities, with the VEPCO stub stapled to the CRT stub. This January 15, 1945, stub shows the overtime required to maintain public transportation during the rationing days of World War II. (Courtesy C. E. and Charlotte Pratt Johnson.)

DETACH AND RETAIN THIS STUB FOR YOUR RECORD

CITIZENS RAPID TRANSIT CORPORATION
EMPLOYEE'S STATEMENT OF EARNINGS
AND PAY ROLL DEDUCTIONS

PERIOD ENDING	EARNINGS	DEDUCTIONS	NET
JAN 15-45	ET 143.75	SS 1.44 PT 12.10 HC 1.03 UB 5.00 🅱 .63	123.50

VIRGINIA ELECTRIC AND POWER COMPANY

STATEMENT OF HOURS WORKED OR ALLOWED

Straight time hours _____ 80 _____

Overtime hours _____ 42 ½ _____

CRT drivers were unionized, as delineated in this agreement from 1947. On July 1, 1956, the drivers voted to reject contract renewal and walked off the job. Picket lines were formed on Victoria Boulevard in front of the carbarn. Many drivers decided not to go back to work for CRT and found employment elsewhere. (Courtesy C. E. and Charlotte Pratt Johnson.)

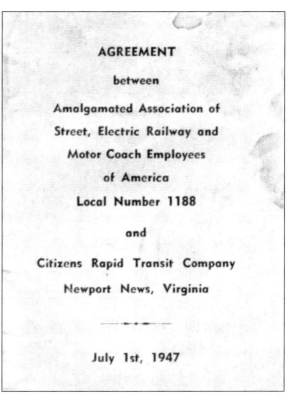

AGREEMENT

between

Amalgamated Association of Street, Electric Railway and Motor Coach Employees of America

Local Number 1188

and

Citizens Rapid Transit Company

Newport News, Virginia

July 1st, 1947

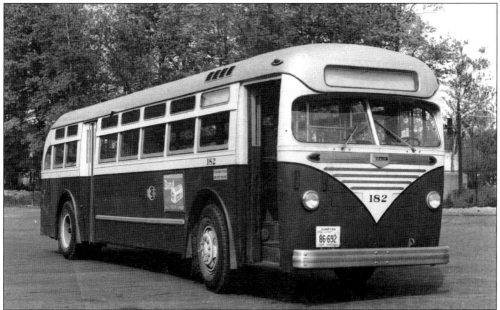

Pictured here is a CRT bus from 1955. They were painted a distinctive red and white, and most of them had Mack diesel engines. These buses carried people from Wythe to jobs, doctor's appointments, shopping, and holidays at Buckroe Beach. Students also rode to junior high and high school, because Hampton did not provide school buses for the upper grades. (Courtesy C. E. and Charlotte Pratt Johnson.)

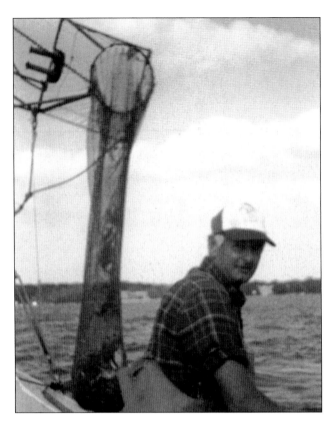

Local crabbers like Pete Freeman are a national treasure of lore about traditional fishing techniques. Patent dip trot lining involved spacing bait along long lines played out from the boat. The boat then turned back at the end of the line and tipped the crabs into a long net basket trailed alongside, seen here hoisted with a crab inside. (Courtesy John "Pete" Freeman.)

Present-day crabbers use wire mesh cages, known as crab pots, which they attach to small colorful buoys. The crabman in his workboat daily pulls up each crab pot in turn, removing the crabs and adding fresh bait. Workboats and buoys are a common sight off Olde Wythe shores. (Courtesy Carolyn Haldeman Hawkins.)

Teledyne-Hastings-Raydist of Hampton, known worldwide for the design and manufacture of precision instrumentation, began in Wythe as Hastings Instrument Company. From its origin in a garage at 117 Hampton Roads Avenue, it moved into the old Robinson oyster/crab processing building and brickyard at 1610 Chesapeake Avenue on July 11, 1947. (Courtesy Carol Hastings Sanders.)

Hastings Instruments vacated the Chesapeake Avenue building in 1949. The site was plagued by drainage problems, which were aggravated by tidal surges; its deathblow came in October 1954 when Hurricane Hazel slammed the peninsula. Tom Hunnicutt bought the property, razed the building, corrected the drainage, and built a new waterside home there in 1966. (Courtesy Tom Hunnicutt.)

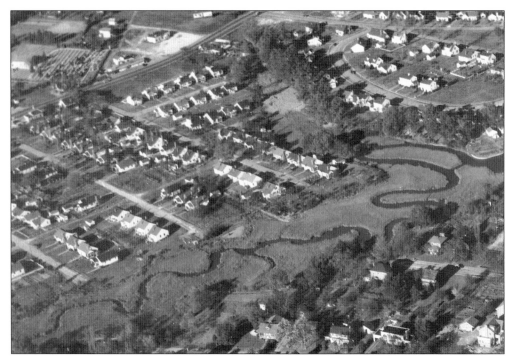

Robert and Inez Edwards bought their house at 106 Hill Street in 1946–1947. Their agent had this aerial photograph made, showing also the loops of upper Robinson Creek. In the marshy area between the Hill Street backyards and Wythe Crescent, the Edwards family kept a boat and caught crabs. Note the Hebrew Cemetery at upper left along Kecoughtan Road. (Courtesy Inez Edwards Dunn.)

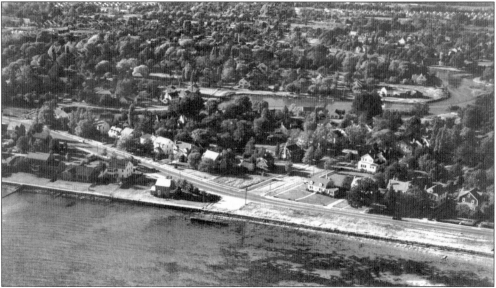

This 1949–1950 photograph shows the Indian River Park area nearly full of houses. In the years since 1916, the tree cover has changed the aerial landscape to green. In the center of the picture, the remnants of the old ferry dock can be seen at the end of Manteo Avenue. (Courtesy W. E. Rouse Library.)

Four

FAMILY, FRIENDS, AND NEIGHBORS

During the housing boom of the 1930s and 1940s, people from all walks of life moved to Wythe: from shipfitters and watermen who fished the waters of Hampton Roads, to soldiers, sailors, and airmen, business leaders, lawyers, and bank presidents. In this growing Elizabeth City County community, they all came together to live, play, and worship.

Wythe was formed from four distinct residential areas along Kecoughtan Road and the Hampton Roads waterway. Within these communities, two schools are located, Armstrong Elementary and George Wythe Elementary, formerly George Wythe Junior High School. A volunteer fire department was created in the early 1920s, which is still active within the community today. Families ate and shopped at the many businesses along Kecoughtan Road and attended the churches in the neighborhood.

Civic associations played a large role in community. In 1919, the Indian River Park Association was formed, bringing together residents bordering Indian River. Other organizations, such as the Wythe Civic Club and Wythe Protective Association, were also involved in the community. In 1980, the Indian River–Robinson Creek Neighborhood Association was formed by the home owners of the Indian River and Robinson Park areas, enacting a neighborhood watch program, an annual Easter egg hunt, fall festivals, and a neighborhood-wide garage sale day. In 1993, with broader boundaries, the Wythe Neighborhood Association was formed. The name was changed to the Olde Wythe Neighborhood Association in 1999 to highlight the historical significance of our area.

Daily life in 1930–1960 Wythe was much like life anywhere else. Families took pride in their homes and neighborhood and worked hard to maintain and improve their property. Children grew up together, playing in the streets, at Robinson Park, along the shore, and in the many creeks that run through the neighborhood. Many of the children were active in the Boy Scouts and Girl Scouts. In 1951, Wythe Little League was formed, and in 1961, the George Wythe Recreational Association built the pool. Children always had plenty to keep them busy.

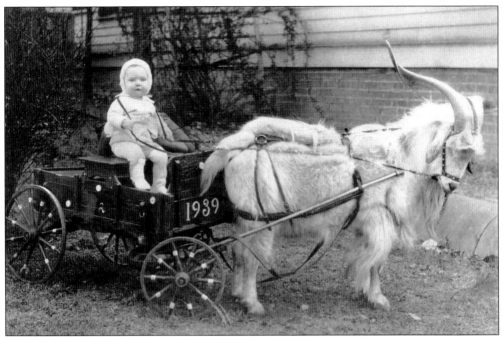

There were goats in Wythe in the 1930s. Small ones were kept to eat brush in the yards, while larger ones were used for milk or to pull wagons in harness. Sears, Roebuck even sold two-wheel carts for the purpose. Traveling salesmen also came around with photogenic animals to take pictures like this one for a fee. The child is Jean Ann Mansfield, at 213 Claremont Avenue in 1939. (Courtesy William Pettitt.)

The six boys of the Raymond Brown ("Coca Cola" Brown) family led active lives, including sailing and riding. This picture was taken in the back garden of their home at 1221 Chesapeake Avenue c. 1939 and shows, from left to right, Zipper, Peter Brown, Tucker, Ray Brown Sr., Billie, and David Brown. (Courtesy John H. Brown.)

The quiet peacefulness of Olde Wythe helped families enjoy simple times together. Bette Ann Croswell is shown here posing for a picture with her grandfather, Poppa Speed, in this 1938 photograph taken at her grandparents' house on what was then Electric Avenue and is now Victoria Boulevard. (Courtesy Bette Ann Croswell.)

Thomas Wirt Sale Jr. grew up at 327 Hollywood Avenue. His father owned the pharmacy at 819 Kecoughtan Road. This *c.* 1931 picture shows young Tom in a cowboy costume with English setter Pal. Tom went into the army at age 18, joining the Third Army as a machine gunner and crossing the Rhine in World War II. After the war, he became a surgeon with a prominent practice in Hampton. (Courtesy Thomas Sale Jr.)

John Q. Hatten's father sold speedboats, cars, and oil. He brought his family to Hampton from Albany, New York, about 1930. They lived at 1221 and then 1205 Chesapeake Avenue. In this picture, John is a college student home on vacation in the early 1940s with his prized 1934 convertible. He went on to become a doctor serving Hampton and Newport News. (Courtesy Selma West Moore.)

Much of the recreation in Wythe centered on the water. In this picture, William and Martin Gracey pose in front of the sailboat they built from scratch by their home at 70 Cherry Avenue. During the warm months of the 1930s, it was not uncommon to see the Gracey brothers sailing their boat back and forth across the Hampton Roads waterway between Hampton and Norfolk. (Courtesy Sebastian Velilla.)

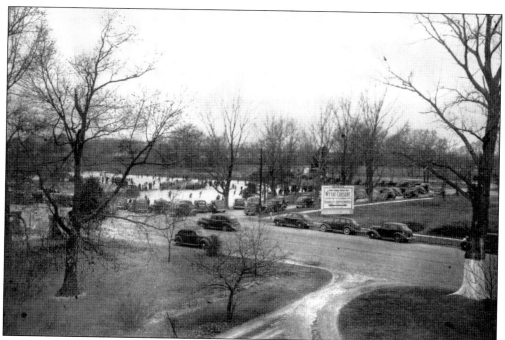

Robinson Creek froze over in 1940, a rare event. The Wythe Volunteer Fire Department flooded the brackish ice with fresh water to prevent the inevitable skaters. This photograph was taken from Tom Robinson's house at 2204 Chesapeake Avenue. Note the billboard for newly opened "restricted" lots on Wythe Crescent. (Courtesy Charles and Elizabeth Zimmerman.)

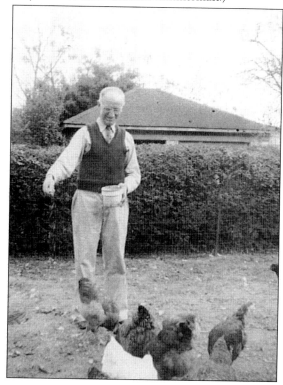

In this 1942 picture, Charles Nelson is tending his chicken run at 140 Powhatan Parkway. During World War II, meat was rationed along with other foods. Many Olde Wythe residents raised chickens in their backyards for food and used their garages for hen roosts to have eggs for their families. Also many victory gardens were planted and shared with neighbors. (Courtesy Warren Wetmore.)

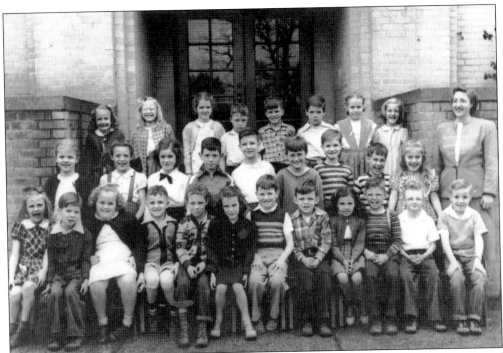

In the late 1940s, Mrs. Stegar's fourth-grade class posed for a class photograph on the steps of Wythe Elementary. In 1950, Wythe Elementary moved from the first Wythe School (which was then torn down) to the 1937 junior high building, both on Claremont Avenue. The new junior high school was at the intersection of Gloucester Street and Catalpa Avenue. (Courtesy Beverly Shelton.)

This photograph shows the February 1948 graduating class of George Wythe Junior High School. Until 1945, students whose sixth birthday was after September 30 but before January 1 were eligible to start school in mid-year; therefore, they had mid-year graduations. This was one of the last such in the original George Wythe Junior High School. (Courtesy Tom Kanoy.)

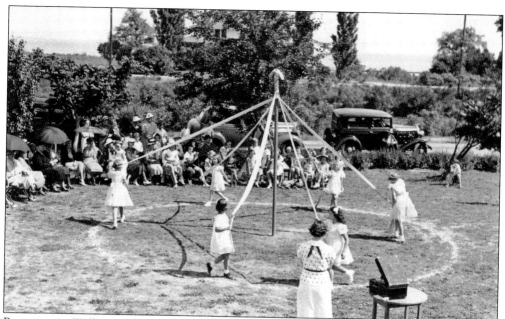

Businessman William E. Rouse built 115 Harbor Drive in 1931 for his daughter Dorothy Bottom's Indian River Park School, which opened about 1933. Her three children attended, along with 20 or so others, until 1939. "Daddy" Rouse also set up a playground in the lot next door, where school festivals and neighborhood sports took place. This June 5, 1936, photograph looks across Indian River toward Chesapeake Avenue. (Courtesy Raymond Bottom.)

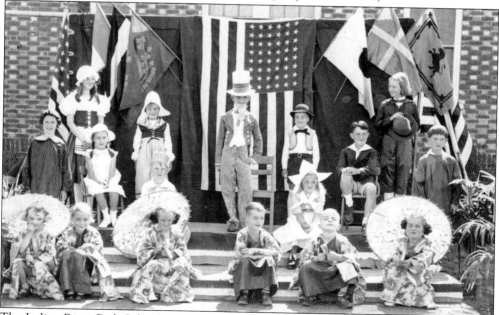

The Indian River Park School at 115 Harbor Drive held dress-up pageants in June each year. This 1937 photograph shows, from left to right, (first row) Jeanne Hootman, Barbara White, Peggy Crowley, Charles and John Llewellyn, and Elizabeth White; (second row) Ray Bottom and Gretchen White; (third row) Rita Fiori, Barbara Bottom, Phoebe Coe, Vincent Fiori (Uncle Sam), John Brown, Joe Healy, Dorothy Bottom, and Donald Russell. (Courtesy Raymond Bottom.)

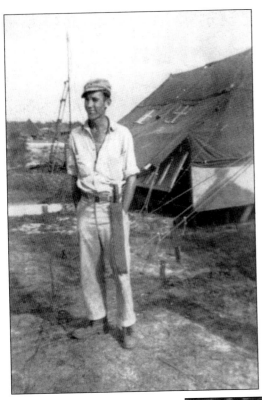

William F. Boerner Jr., of 403 Raleigh Avenue, enlisted in the Army Air Corps in 1943. He was in the Pacific Island–hopping campaign, including a short but exciting interlude left ashore in Leyte between assault attempts. This photograph was taken at Leyte soon after that. After the war, he mustered out, then returned to the Air Force for 10 years before settling down again in Hampton. (Courtesy Jack Boerner.)

John Boerner ("Jack," left) grew up at 403 Raleigh Avenue. He joined the Marine Corps in 1951, arriving in Korea at the beginning of the Pusan breakout. After the armistice, he participated in the 1953 nuclear tests before transferring to the reserves in 1954. In this 1953 photograph, little brother Robert (right) had just completed Marine Corps boot camp. (Courtesy Jack Boerner.)

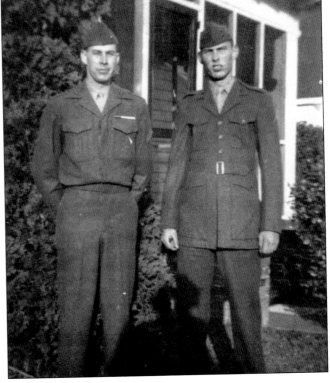

Joseph C. Howard III joined the army in 1949 and served with distinction in the Korean War. He was wounded four times, requiring years of medical treatment, and was decorated for bravery by Gen. Mark Clark. Joe grew up on Manteo Avenue and introduced Jack Boerner to his bride, Mary Caroline Welch. (Courtesy Jack and Mary Caroline Boerner.)

Will Granger joined the Army Air Corps from San Antonio, Texas, serving in the European theater in World War II. After the war, he signed up for pilot training, as seen in this photograph. He flew in the Kyushu Gypsies in the Korean War, then came to Langley Air Force Base, married an Olde Wythe resident, and settled down on Chesapeake Avenue. (Courtesy Barbara Granger.)

During World War II, the young women of Wythe supported the war effort. With its proximity to military installations, including Norfolk Naval Base, Fort Monroe, Fort Eustis, and Langley Field, Hampton experienced quite an influx of soldiers bound for war. In this picture, Evelyn Ann Gatewood (second from right) and other members of the United Services Organization (USO) are extending local hospitality to homesick soldiers. (Courtesy Bette Ann Croswell.)

Fred Ferrari Jr. (center), of 1203 Electric Avenue (now Victoria Avenue), apprenticed at the shipyard in March 1941. He worked on seven aircraft carriers, shipping out on the last one (USS *Randolph*). He was at Iwo Jima, the Philippines, Okinawa, and Tokyo Bay. While the *Randolph* was in for refit, he went to Hollywood, where he got passes to a movie studio. (Courtesy Fred Ferrari Jr.)

Lewis Whitehouse was in navy underwater demolition in World War II, clearing beaches ahead of the Marines at Lingayan Gulf, Guam, and Iwo Jima. This photograph was taken on leave in June 1945 with his wife, Mary Verell Whitehouse, at her brother's home, 259 Little Farms Avenue. (Courtesy Lewis Whitehouse.)

Charles K. Potter went to war as a navy radio technician third class. He spent much of the time on Saipan. Upon his return to Hampton for discharge in 1946, he discovered that his best friend's little sister had grown up. Mary Jacqueline ("Jackie") Pettitt had just graduated from high school at age 16. They were married in 1948. Jackie and Charlie are shown with her mother, Lillian, at 138 Claremont Avenue. (Courtesy Jackie Potter.)

Russell M. Ward ("Mike"), originally of Newport News, was drafted into army field artillery in December 1942 and was at Normandy on D-Day. This photograph shows Mike (center) and fellow messengers in Holland in 1944. He was recalled to service in 1950, arriving in Pusan, Korea, to the sound of enemy artillery. He survived and settled down with his wife, Yvonne, at 37 Apple Avenue. (Courtesy Mike Ward.)

Willie Norris was a military aircraft mechanic from 1921 to 1951, serving in the Army Signal and Air Corps, the Army Air Forces, and the Air Force. His World War II duties spanned the globe, first in Europe, then India, and finally the Pacific. Afterward he and his wife, Winona, lived with her parents, Irvin and Edna Walton, at 329 Cottonwood Avenue before settling down on Victoria Boulevard. (Courtesy Tom Norris.)

Robert Crouse, brother of Elizabeth Chapman, grew up at 81 Algonquin Road, the son of an agriculture professor at the Hampton Institute. He was drafted into the Army Air Corps in 1941, serving in World War II, Korea, and Vietnam. He logged over 16,000 flying hours as a flight engineer in B-24, C-124, and C-141 aircraft before retiring in 1973. (Courtesy Jack and Mary Caroline Boerner.)

Peter M. Brown, second son of Raymond and Evelyn Brown, had a passion for flying. He learned to fly at 16 and kept his own aircraft at Patrick Henry Airport. In this 1953 photograph, Ensign Brown had just received his naval aviator's wings. In March 1953, he was killed in a training accident in Texas while flying a TV-1 Shooting Star. He was 23 years old. (Courtesy John H. Brown.)

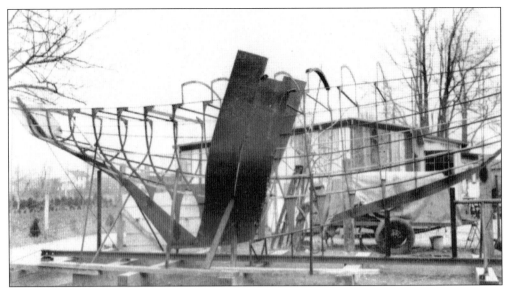

For much of its history, Wythe was a rural community alongside Hampton Roads. This 1940s photograph of the steel-hulled sailboat *Skipper* under construction in the Ferrari family's Electric Avenue yard fits right in. Upon completion, the boat was hauled by truck down Electric Avenue through the Victory Arch in Newport News, where it was launched. (Courtesy Fred Ferrari Jr.)

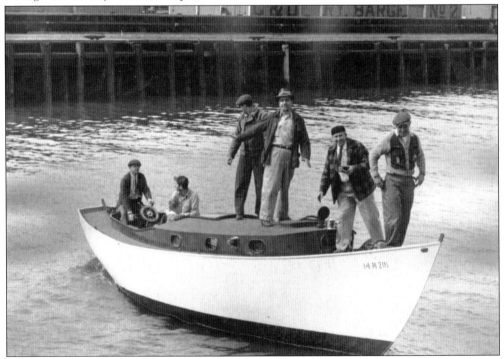

In this 1946 photograph, the *Skipper* is shown on its maiden voyage. Aboard are, from left to right, Jimmy Torok, Ugo Tuccori, Fred Ferrari Jr., and Frank Tuccori, all of whom were involved in the construction; George Walters, an architect who later sailed the boat; and Capt. Eddie Haldeman, who supervised the whole project. The mast still has not been raised. (Courtesy Fred Ferrari Jr.)

Ray Hooker was very active in the Hampton Yacht Club, including a term as commodore in 1958. In this late 1940s photograph, Ray (left rear), daughter Anne (right rear), wife Mary Anne (left front), and son Willard (right front) have just returned from an outing in their Penguin-class sailboat. Six-year-old Willard has just been fished out of the drink and is sopping wet. (Courtesy Ray Hooker.)

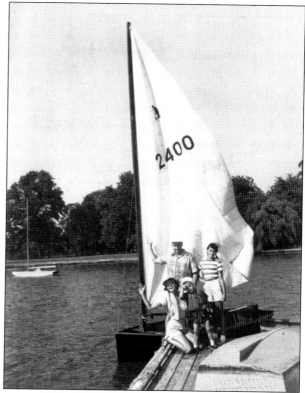

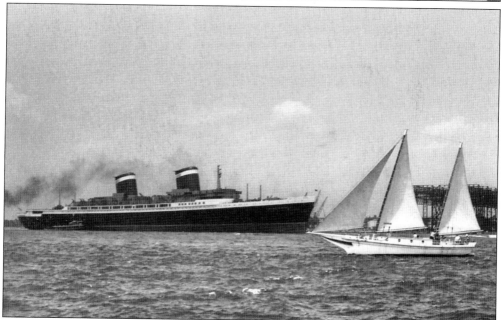

Sailboats have always been a common sight in the waters off Olde Wythe's shores. In this photograph, the *Gypsy* sails by the SS *United States* as the latter steams past Newport News Point. The *Gypsy* was a well-known boat in Olde Wythe and belonged to Charles H. Hewins, who would give neighborhood children rides. (Courtesy Ann Curfman.)

Church functions, like this Tom Thumb wedding at Aldersgate United Methodist Church, were big social draws for the community. In this picture, the groom, Buddy Norris, and bride, Judy Ham, pose with the wedding party. Guests included Alice in Wonderland, Little Boy Blue, Little Jack Horner, and Old Mother Hubbard. Local businesses from Hampton and Newport News sponsored the event. (Courtesy Beverly Shelton.)

For 56 years, H. J. "Jake" Jacobson played piano and organ for Aldersgate United Methodist Church. Jake joined Aldersgate in 1939. Mrs. Lewis, the young people's choir director, asked him to play the piano for their rehearsal. The Reverend Frank H. VanDyke Jr. heard him play in 1940 and asked him to be the regular church pianist. Jake has lived in Olde Wythe all his life, currently on Pear Avenue. (Courtesy Richard Jacobson.)

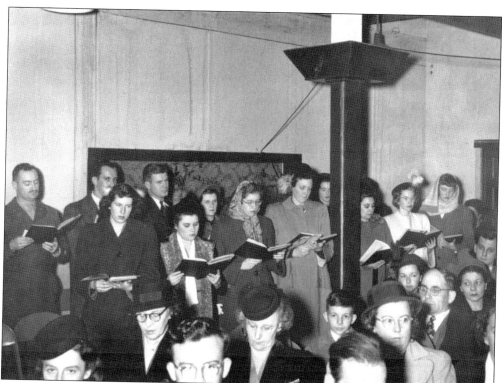

Beginning in July 1948, the new Catholic parish of St. Rose of Lima filled a need for worshippers who had previously gone to Phoebus or Newport News. The parishioners soon filled the Parish Hall in the World War II temporary recreation facility. This photograph shows the first Christmas Midnight Mass, in 1948. Mary Caroline Welch is the first woman on the left in the choir. (Courtesy Mary Caroline Boerner.)

Harold and Elizabeth Crouse Chapman were noted local musicians. They both taught music, he piano and she violin and viola. He played the organ at St. John's and was also a composer. One of his works heard often in past years was Williamsburg's "The Common Glory." This 1960s picture shows Elizabeth and Harold at 127 East Avenue. (Courtesy Jack and Mary Caroline Boerner.)

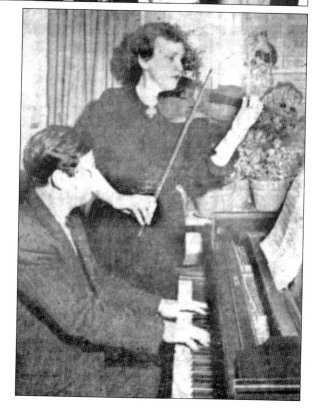

Robinson Park, located between Braddock Road and Robinson Road, is in the center of Olde Wythe. Horsing around at the park during their courtship in 1949 are Barbara Sims and Benjamin "Puggy" Smith. The park at that time was home to different types of playground equipment and the Park House, a covered shelter where family gatherings and neighborhood social events were held. (Courtesy Benjamin Smith Jr.)

Even as late as the 1950s, Wythe still had a rural flair. Many families kept horses, using their garages as stables. The Colemans of 211 La Salle Avenue kept ponies, and it was not uncommon for the children of Olde Wythe to stop by for rides. In this 1946 photograph, Tommy Coleman sits atop one of the ponies. (Courtesy Tommy Coleman.)

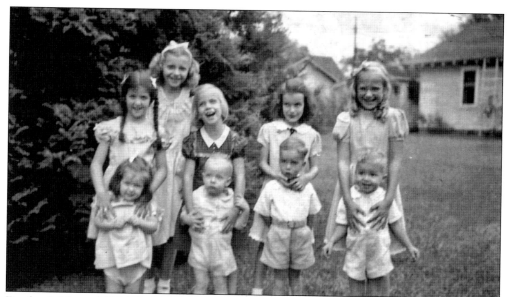

For the children of Olde Wythe, there was never a shortage of fun things to do. In this photograph, Kathy Clark, Margaret Clark, Anna Marie (Flitzie) Thompson, Shirley Alm, Ned VanDyke, Virginia Lee Kemp, Stanley Lathann, Beverly Jacobson, and Doug Jacobson celebrate Doug's birthday on October 2, 1948, at 146 Pear Avenue. (Courtesy Beverly Shelton.)

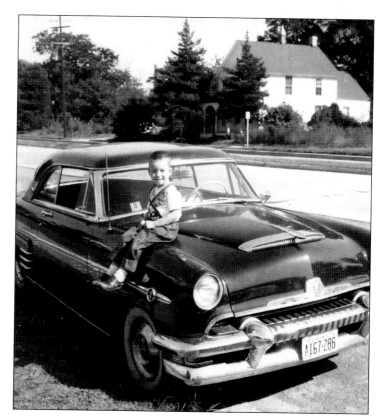

Here is Tom Norris sitting on the fender of brother-in-law Bill Kanney's black 1954 Mercury in September 1959. This photograph was taken in front of Tom's house at 3729 Victoria Boulevard. Visible between the trees in the upper left is the smokestack of the old VEPCO Sunset Creek power station, which was built to supply electricity to the trolley lines as well as residents. (Courtesy Tom Norris.)

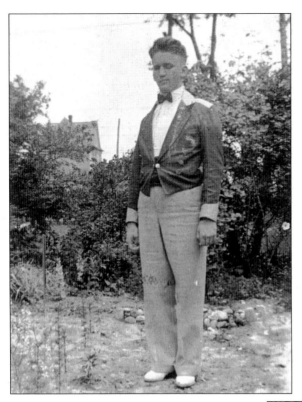

Blair Blanton was a local musician. Although blind, Blair was an avid piano player. In this picture, he is shown in his orchestra uniform at his home on O'Canoe Place. In addition to playing the piano, Blair also repaired pianos for local residents in his garage. (Courtesy Helen H. Blanton.)

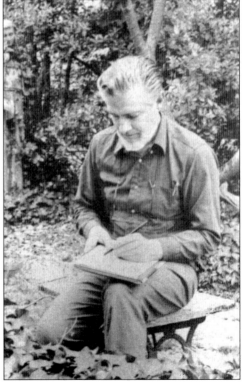

Allan D. Jones Jr. was the son of the noted lawyer and early Indian River Park developer. His paintings were widely exhibited in shows and galleries. During World War II, he worked at the Hampton Roads U.S. Army Port of Embarkation, sketching events for posterity. This 1960s photograph was taken in the garden of 44 Claremont Avenue, where he lived with his equally accomplished artist wife Jean Craig. (Courtesy Dylan Jones.)

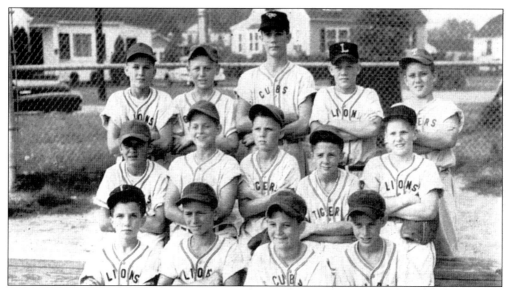

Little League baseball started in 1954, with teams playing on fields throughout Olde Wythe. In the early 1980s, Hampton City Schools gave the league a permit for the maintenance of fields behind Wythe Elementary. The league then built grandstands and a refreshment stand. This picture shows the 1954 Wythe team, the only team from District 7 in Virginia to ever play in the Little League World Series. (Courtesy Wythe Little League.)

Charles Sexton is handed the gavel of office in this 1966 photograph of his installation as president of the Wythe Civic Club. The ceremony was held at the Oasis Restaurant. Pictured from left to right are Hampton city manager C. E. Johnson, Joseph Bristow, Charles Sexton, V. C. Delp, John Carter, R. E. Redding Jr., and Claude Tatman. (Courtesy Gloria Sexton.)

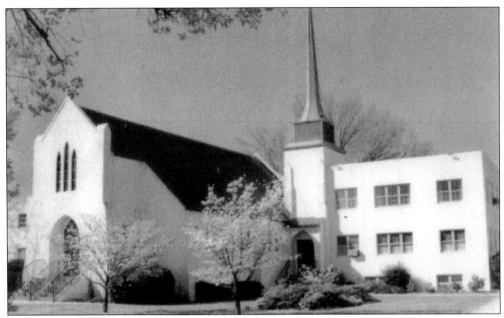

Wythe Presbyterian Church started in 1921 as an outpost Sunday school of the First Presbyterian Church of Newport News. It chartered in 1940 with 25 members. In 1949, services began at the Kecoughtan and Robinson Roads site. With continuing growth, streetcars were used as classrooms before the church added to its building. In 1964, about 200 members were lost when the NASA space control mission moved to Houston. (Courtesy Wythe Presbyterian Church.)

Aldersgate United Methodist Church, originally St. John's Methodist Episcopal, changed its name in 1938 to avoid confusion with St. John's Episcopal Church of Hampton. The first service was in 1937 in the tiny Cottonwood Avenue chapel. In 1940, they moved to Wythe Parkway and Kecoughtan Road. This 1959 picture shows the groundbreaking ceremony for an addition. (Courtesy Aldersgate United Methodist Church.)

Temple B'nai Israel relocated from downtown Hampton to the corner of Kecoughtan and Allegheny Roads in 1958. Pictured is the parade of the Torahs into the new sanctuary, led by Rabbi Marvis, followed by Herbie Goldstein, a prominent local businessman who lived on Hampton Roads Avenue. The girl in the background holding the Ten Commandments is Susan Sandler, writer of the 1980 movie *Crossing Delancey*. (Courtesy Temple B'nai Israel.)

Located on Kecoughtan Road, the Orthodox Hebrew Cemetery had its first interment in 1889. In 1937, Alan Rosenbaum sold land next to the Hebrew Cemetery for a cemetery for other Jewish denominations, named the Rosenbaum Cemetery in his honor. With two entrances, both cemeteries shared the main drive, with a fence going down the middle. In the 1970s, the two cemeteries were made into one, using just the larger Hebrew entrance. (Courtesy Gregory Siegel.)

Mrs. Bowman's first-grade class at Armstrong School in 1946 all lived east of Indian River, the dividing line for the schools in the area. This picture includes Melanie Canny, Johnny Kaiser, Ralph Goldstein, Warren Wetmore, Jane Spencer, Ann Hill, Jerry Stillwell, Bill Brock, and Melissa Farster. (Courtesy Warren Wetmore.)

A student show at George Wythe Junior High School is shown in this 1950s picture. In addition to being a site of local presentations, the facility was also used by Newport News High School during 1953 and 1954 after its own auditorium was destroyed by arson on December 28, 1952. (Courtesy Eleanor K. Hubbard.)

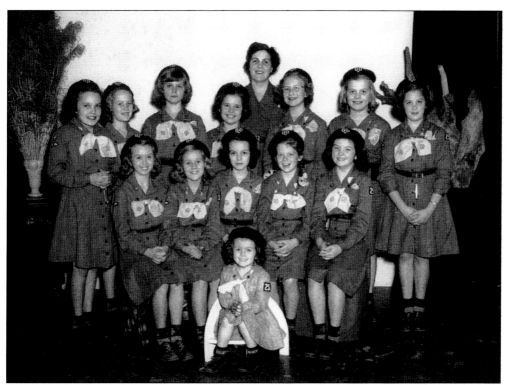

Among Wythe's active Boy and Girl Scout troops was Girl Scout Troop No. 25, a national award–winning troop. Pictured from left to right are (first row) Margaret Clark, troop mascot; (second row) Joyce Ann Gray; Nellie Horsely; Virginia Lee Kemp; Martha Grant; and Kathryn Clark; (third row) Jane Ross Knowles; Rita Martin; Joanne Smith; Carolyn Green; Mrs. P. H. Clark, troop leader; Beverly Jacobson; Nancy Powell; and Peggy Saunders. (Courtesy Beverly Shelton.)

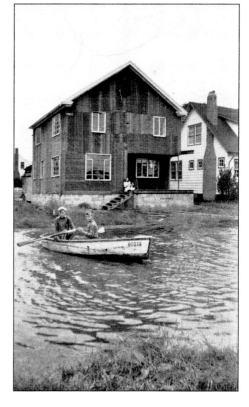

This snapshot at 301 Harbor Drive was taken by Dave Dutrow in October 1947. It was neither flood nor hurricane, just an unusually high tide on India River. Bob Boerner (left) and Clark Woodcock, both of Raleigh Avenue, are in the boat *Boots*, which was kept at a small dock nearby. Mrs. Dutrow is on the porch. (Courtesy Jack Boerner.)

Olde Wythe was a great place to grow up. From fishing and crabbing in the creek to riding bikes in the street, there was no shortage of fun. Tommy Phillips (left), Richard Sawyer (center), and Joe White pose for this 1962 picture outside the Sawyer home at 134 Pocahontas Place. (Courtesy Richard H. Sawyer.)

You can tell by the vintage clothes and car that this picture was taken in 1970. Janice Pratt McGrew is standing with her 1969 Volkswagen Beetle in front of 121 Hampton Roads Avenue, with 120 and 126 Hampton Roads Avenue in the background. The Hampton Roads Golf Course was in this area in the early 1900s. (Courtesy Janice Pratt McGrew.)

In August 1966, Ronald L. Cain and Betty T. Cain were married at Wythe Parkway Baptist Church. The church, actually at 2200 Bay Avenue, suffered a fire a few years later, after which the congregation moved to a new location near Big Bethel Road and changed its name to Big Bethel (now Faith) Baptist Church. The old building is now Fountain Baptist Church. (Courtesy Betty Cain.)

Dr. William Goldsmith came to take care of World War II shipyard workers. He married a visiting New Yorker, and they chose to make their life in Indian River Park. They built a medical building at 2612 Kecoughtan Road (now apartments). In the 1970s, Gloria Goldsmith led the drive for the Wythe fire station's new mobile cardiac arrest unit. (Courtesy Gloria Goldsmith.)

Ada Ridout's grandfather piloted a Civil War blockade-runner out of Hampton to get food to the Confederates in Petersburg. She lived at 375 Catalpa Avenue and was very active in neighborhood affairs. This quilting bee was somewhere in Wythe in the 1970s and shows, clockwise from top right, Ada Ridout, Clara Fowlks, Crystal Roane, Betty Stopski, Mrs. Berry, Mary Ford, Anna Lewis, and Mrs. Turner. (Courtesy Virginia LaNeave.)

In 1983, Michael Cobb of Pocahontas Place received a new bike for his birthday. Mike, like many kids in this neighborhood, took to the sidewalks to explore. Besides bike riding, kids throughout the area fished and crabbed off the Powhatan Bridge, played Little League ball, and joined Scouting. Mike's dad, Jerry, grew up on Kenmore Drive. (Courtesy Jerry and Sandy Cobb.)

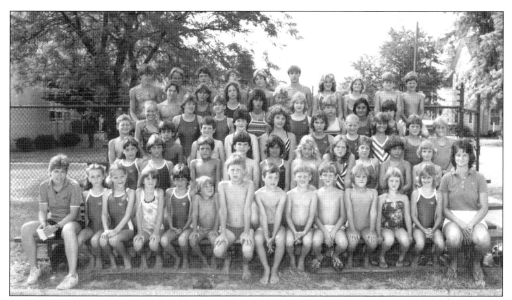

In 1961, a small group of Olde Wythe residents organized to create a recreation facility for the growing community. They leased a small parcel of city land beside Wythe Elementary and borrowed $30,000 to build a swimming pool. With this, the George Wythe Recreation Association was born. Thousands of Wythe children learned to swim and competed on the swim team, called the Wahoos. (Courtesy William Robertson and family.)

Robert Lee Webb was the son of Paul Webb, president of the American Institute of Banking. He grew up in the house Paul built at 2918 Chesapeake Avenue. Lee joined the fire department in 1973 and became one of Hampton's first paramedics. Lee achieved his lifelong ambition of becoming the Wythe battalion chief in 1998, just before cancer brought him down. (Courtesy Maureen Webb.)

Hampton, like much of Tidewater, is a military town. Olde Wythe is no exception, and it is proud of its veterans. This photograph was taken in 2006 in front of the Welcome to Olde Wythe neighborhood sign to capture the images of some of Wythe's veterans. Pictured are, from left to right, as follows: (first row) Carol King (USAF), George LeCuyer (USAF), Anthony Soltys (USA), and Heidi Brown (USAF); (second row) John Bishop (USA), George Brown (USAF), Charles Brown (USN), Mike Ward (USA), Fred Ferrari (USN), Albert Hale (USA), and Willard Granger (USAF); (third row) Reg Soule (USA), Mike McHenry (USN and USA), Tom Kanoy (USNR), Mike Davenport (USAF), Thomas Sale (USA), Joseph King (USA), and Bruce E. Dunlap (USA). (Courtesy Anne McHenry.)

Five

A WALK THROUGH OLDE WYTHE

As one walks the streets of Olde Wythe, it is hard not to notice the diverse architecture of the many homes in this quiet seaside community. This architectural diversity lends testimony to the age and the rich historical roots of the neighborhood, with at least one home that predates the Civil War to new homes that continue to be constructed to this day. This steady process of development has resulted in a neighborhood with no sense of architectural cohesion but acts as a timeline to tell the stories of the lives and events that created and continue to build Wythe.

Olde Wythe's wide range of size and value of homes can be attributed to the neighborhood's proximity to the waterfront and its location as a midpoint between the cities of Newport News and Hampton. While most of the neighborhoods in Hampton and Newport News are economically segregated, both economic extremes can be found within Olde Wythe. Along the waterfront, large homes once belonging to ship captains or houses once serving as summer homes can be found. However, the majority of Olde Wythe is a working-class community started as a planned streetcar suburb to Newport News and Hampton. As one gets further from the water, the homes become noticeably smaller.

While it is possible to find large Queen Anne, Colonial Revival, and Tudor Revival homes along Chesapeake Avenue, many of the homes in Olde Wythe reflect the bungalow and Craftsman style that became prevalent just after 1900.

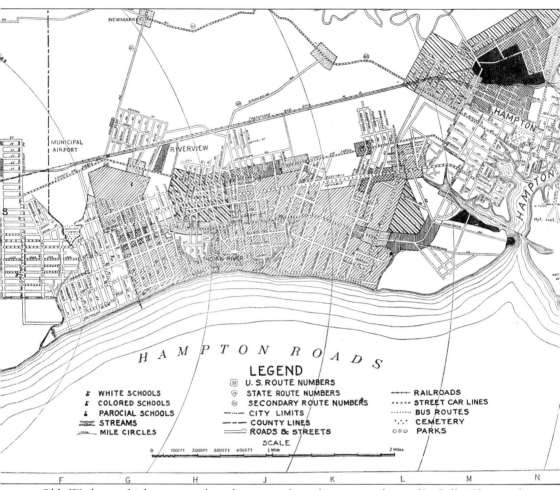

Olde Wythe was laid out in rough grid patterns along the streetcar lines of La Salle, Chesapeake, and Electric Avenues. In addition to the early mansions along the shore, the first developments were started along the inland roads. Olde Wythe is actually a compilation of four distinct residential areas: homes constructed through the Armstrong Development Corporation along the eastern end of Olde Wythe; Indian River Park surrounding Indian River; J. C. Robinson's development in the Wythe Crescent and Robinson Creek area; and homes constructed through several Newport News land companies along the western edge of Olde Wythe and also occupying part of what is today Newport News. These areas can be seen on the map above. The map shows that while Olde Wythe is and was economically diverse, it, like much of the South, was not racially integrated until the 1960s. In fact, many deeds into the 1930s included a restriction that specifically forbade the sale of the property to "coloreds" or Chinese as they were stated to be unsanitary. This clause is no longer enforced in today's diverse Olde Wythe. (Courtesy a 1940 county zone map by R. F. Bower, now in the public domain.)

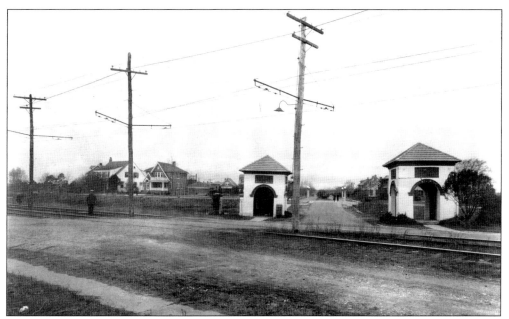

This 1933 photograph is of the Chesapeake Avenue entrance into Indian River Park. The photograph is looking up Powhatan Parkway away from Hampton Roads Bay, and the old Indian River Bridge can be seen in the distance. In the foreground, the streetcar lines are visible. The two entrance lodges to either side of the road are streetcar stops and are no longer present. (Courtesy *Daily Press* Archives.)

The current Powhatan Parkway bridge over Indian River is a distinctive feature of Olde Wythe. The bridge, constructed in 1997, is a replica of the previous, 70-year-old bridge. It is a unique timber construction with cobblestone-style pavers and steel railings. The lanterns are replicas of the original old electric lanterns that lit the streets of the Indian River Park community. (Courtesy Sean and Debbie Hancock.)

The Gilliland house, located at 3629 Chesapeake Avenue, is the oldest house in Olde Wythe and possibly the only home in the neighborhood dating from the antebellum era. Built in 1849, the Gilliland house is a good example of the vernacular Greek Revival style. The most prominent feature in this picture is the front entryway surrounded by a rectangular transom and sidelights. (Courtesy Helen Sampson.)

This farmhouse at 41 Orchard Road beside Robinson Creek was built in the 1880s. The home once served as an oyster shucking and packing house. Oysters were brought via Robinson Creek to the house, where they were processed. The side yard of the house still has a 10-foot-thick bed of oyster shells. (Courtesy Helen Sampson.)

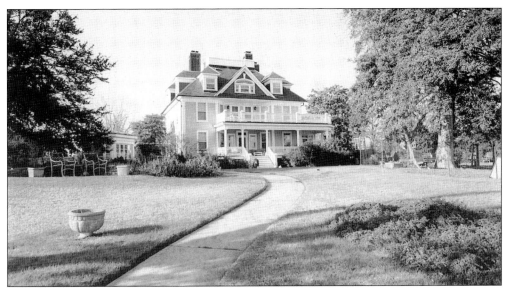

The Robinson house, located at 1500 Chesapeake Avenue, is one of the landmark homes of Olde Wythe. The house was built in 1900 and is one of only a few Victorian Queen Anne homes located within the community. The house was once home to Captain Robinson, who founded Robinson's Oyster Packers and donated the land for Robinson Park to the neighborhood. (Courtesy Carol King.)

The Bayside, located at 3013 Chesapeake Avenue, was constructed in 1899 for Mrs. Wentworth. Oddly enough, the original facade was not brick and stone as seen here, but was changed later in 1913. Even so, the home still bears many trademark features of a Queen Anne, including the dominant front-facing gable with Palladian window, the large porch with columns, and the rounded front bay window. (Courtesy Sean and Debbie Hancock.)

This small cottage-style home located at 58 Cherokee Road was built in 1927. The house served as the groundskeeper's house for the large white manor Victorian house pictured below at 3505 Chesapeake Avenue. Today the unique little home fits very well into the eclectic architecture of Olde Wythe. (Courtesy Sean and Debbie Hancock.)

This home at 3505 Chesapeake Boulevard was one of the first homes built along the Boulevard. It was built before 1905, when it was the home of Mary McMenamin. Her father, James, perfected the process of packaging fresh crabs for shipping. The large turret and broad hipped roof are just a few of the notable features of this fine old Queen Anne. (Courtesy Helen Sampson.)

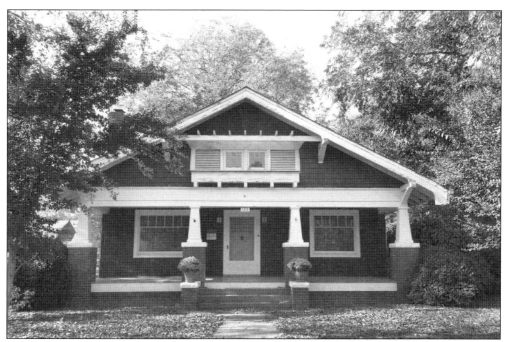

The home at 133 Powhatan Parkway was built in 1922 and is an excellent example of a front-gabled bungalow. Its wide overhanging eaves give the appearance of wings, giving rise to the name "airplane bungalow" for this type of house. The exposed rafters and five- and six-over-one sash windows are common among bungalows. (Courtesy Helen Sampson.)

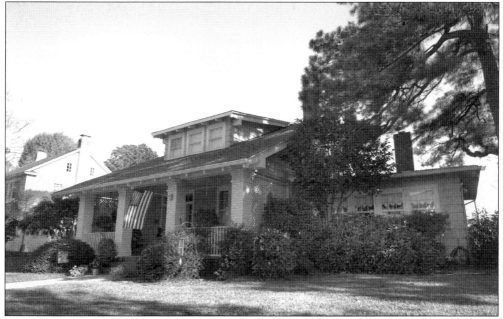

Built in 1904, this house at 102 Powhatan Parkway is another example of a bungalow. The home is one-and-a-half stories, typical of most bungalows, and again has many common bungalow features, including a low-pitched side gabled roof, incised porch, and exposed rafters. (Courtesy Helen Sampson.)

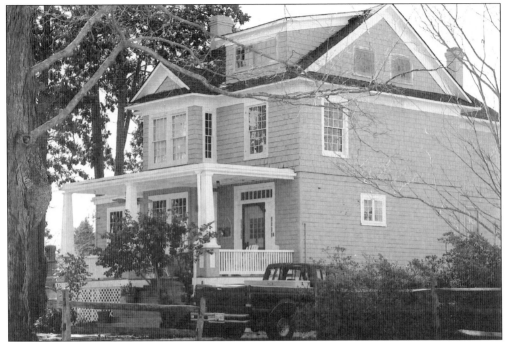

Edward and Anna Randolph built this house at 35 Hampton Roads Avenue in 1909. Anna was the first female doctor on the peninsula. The home's Arts and Crafts style is reflected in the mixture of wood clapboard and shingle siding, the broad front porch with its large square columns, and the muted color and appearance of the home. (Courtesy Sean and Debbie Hancock.)

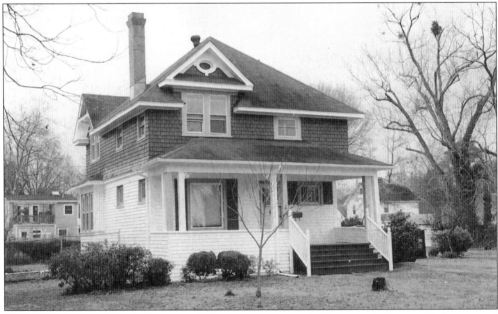

This 1900 Arts and Crafts home at 49 Locust Avenue probably started life as a kit home, and at first glance, it shares many of the characteristics of an American Foursquare. Like the home at 35 Hampton Roads Avenue, it is constructed of clapboard and shingle siding. This home also has a large front porch with enclosed rails. (Courtesy Carol King.)

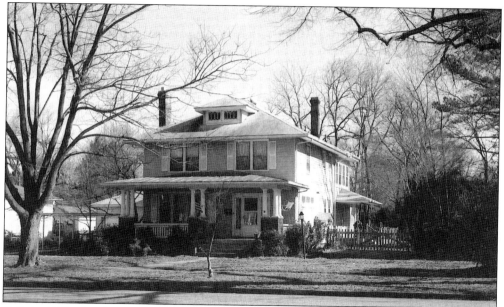

Built in 1918, this American Foursquare home at 44 Hampton Roads Avenue is an example of another very popular style in Olde Wythe. The low-pitched hipped roof with deep overhang, boxy shape, large central dormer, and wide stairs are all features common to this design. Billed as a home that gets you the most space for your buck, these homes are common in Wythe. (Courtesy Sean and Debbie Hancock.)

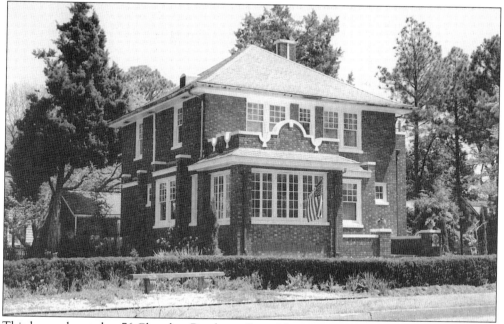

This home, located at 76 Cherokee Road, is a Sears Honor Bilt kit home. This home is one of many homes in the neighborhood that were manufactured from mail-order kits. This particular home is Modern Home No. 2090—the Alhambra—from the Sears Modern Homes Mail Order Catalog available from 1915 to 1920. Originally this home had a stucco facade, but Dr. Berlin bricked the home over later. (Courtesy Helen Sampson.)

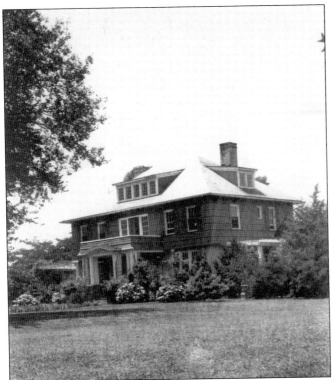

While it doesn't look much like this today, this home, located at 1221 Chesapeake Avenue, is commonly referred to as the Coca Cola Brown house after Raymond M. Brown, who owned the local Coca-Cola distributorship. This home, built before 1924, is a rare example of a two-and-a-half-story bungalow-style home. After purchasing the home in 1933, Brown had it renovated. The result is the house pictured below. (Courtesy John H. Brown.)

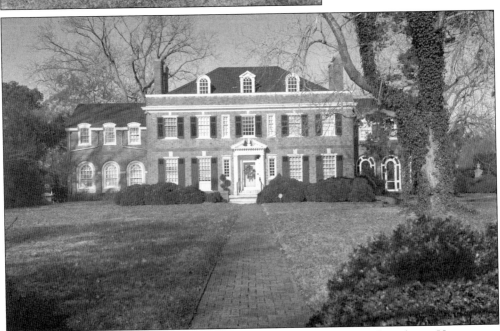

The renovation was originally intended as just a remodel of the bungalow above. However, as work progressed, the two wings were added and the home was transformed into this Colonial Revival Georgian. The exterior was designed by Newport News architects Coile and Pepino. The interior was gutted and redesigned by Duncan Lee, the renovation architect of Carter's Grove. (Courtesy Helen Sampson.)

The Prairie-style home at 2212 Chesapeake Avenue was designed by Williamsburg architect Wright Hougland for Mr. and Mrs. Sherwood Hornsby in 1970. The Prairie style, heavily influenced by Frank Lloyd Wright, is typically a single story with a hipped roof and broad eaves. The long bands of windows seen on this home are common to the style. Prairie-style homes often have Japanese influences, which have been accentuated in this house. (Courtesy Sean and Debbie Hancock.)

The unusual home at 1400 Chesapeake Avenue has many nicknames: "Tugboat House," "Icebox House," and "Art Deco House." Built in 1935 using plans featured at the 1935 World's Fair, it is a Spanish/Mission Revival. Rare outside the Southwest and Florida, this style includes low-pitched roofs, a prominent arch over the door, and an asymmetrical stucco exterior. (Courtesy Helen Sampson.)

Built in 1940, this home at 116 Braddock Road is a typical Cape Cod and is representative of many of the homes surrounding Robinson Park. This Cape Cod is of the dormered Williamsburg style with a one-and-a-half-story side-gable plan, sidewall chimney, central stoop, and Colonial-style roof dormers. (Courtesy Sean and Debbie Hancock.)

This Georgian Revival home at 2308 Chesapeake Avenue was designed by Bernard B. Spigel and built in 1949. The home has two formal entrances, which is common among waterfront homes. The spiral staircase that defines the main entryway was designed and built by Joseph Pereira as a smaller version of the grand staircase he built for the SS *United States*. (Courtesy Helen Sampson.)

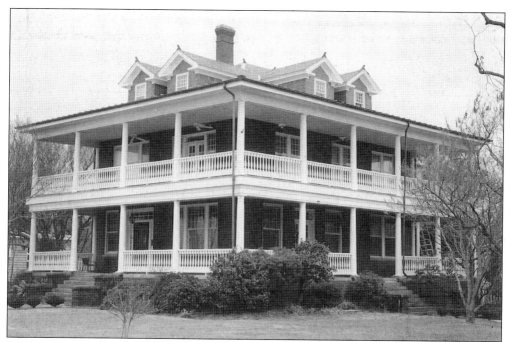

The home located at 3637 Chesapeake Avenue was built in 1916 and was once the home of Manning Kimmel, brother of Adm. Husband E. Kimmel, commander in chief of the Pacific fleet at the outset of World War II. The home is of the coastal neoclassical design as indicated by the multi-level porches. The porches were used for both the enjoyment of the water view and to provide protection against the elements. (Courtesy Carol King.)

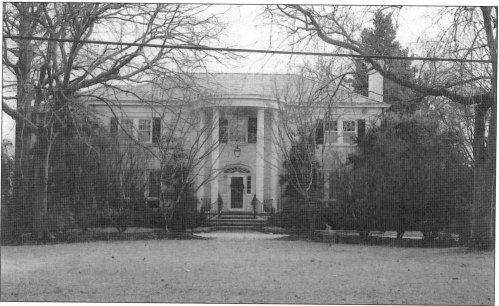

The home at 2214 Chesapeake Avenue is a good example of a neoclassical Revival. This style is not typically used for homes but more often found in banks and federal buildings. This may be the only example of this style in Olde Wythe. Built in 1955, it has a distinguished full-height porch with columns characteristic of this style. (Courtesy Sean and Debbie Hancock.)

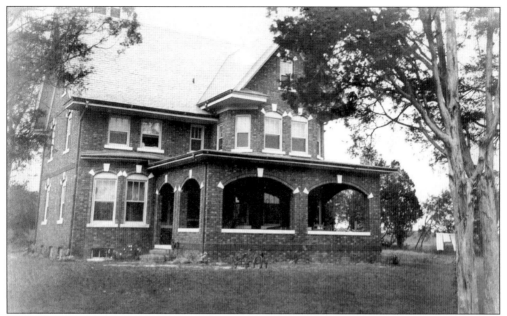

This German-influenced home at 2204 Chesapeake Avenue was built in 1929 by Tom Robinson, son of Capt. J. C. Robinson, according to plans he drew up himself. Some unique traits to this home are the distinctive keystones and the Flemish bond brick. The photograph is actually of the rear of the house, facing the Hampton Roads waterway. (Courtesy Charles and Elizabeth Zimmerman.)

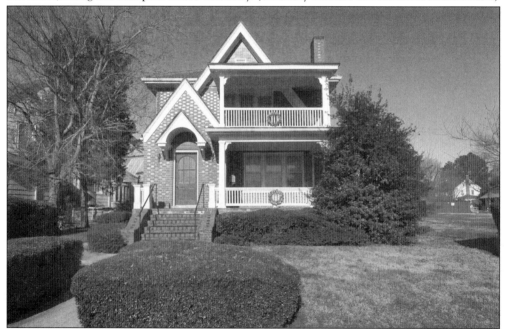

The W. E. Rouse Library occupies this house at 115 Harbor Drive. William Rouse built it in 1931, with an apartment on the second floor for himself and his sisters. His daughter, Dorothy Rouse-Bottom, ran the Indian River Park School on the first floor. The house is of the Cottage style with German and Swiss influence. This home is also built with Flemish bond brick. (Courtesy Helen Sampson.)

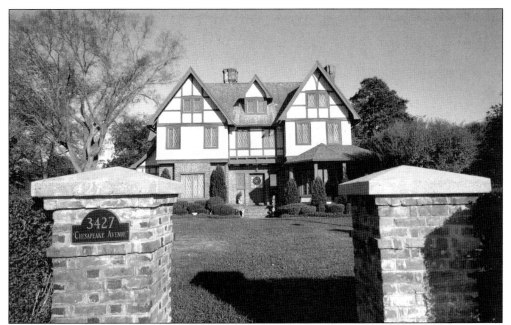

This large Tudor home located at 3427 Chesapeake Avenue was built in 1903 by Mrs. William (Mary Frances) Armstrong for John Shanahan. The home has all of the common traits of a Tudor Revival home, including a high-pitched roof, stucco and masonry walls, and the trademark ornamental half timbering. The home also served as Miss Porter's School into the 1970s. (Courtesy Helen Sampson.)

Charles "Tom" Augustus Jr. designed and built the home at 40 Manteo Avenue in 1938. The home is an Elizabethan Tudor-influenced cottage. The battered chimney on the front is a hallmark of the cottage style. Tom Augustus Jr. is said to have designed the home from his imagination while attempting to create a home reminiscent of his native Germany. (Courtesy Sean and Debbie Hancock.)

This French Colonial Revival house, at 501 Harbor Drive, was built in 1918. While serving in World War I, Franklin Lenz saw this style of house overseas and liked it so much that he had this one constructed from memory. The home bears typical French Colonial Revival hallmarks, including stucco siding, symmetrical and square architecture, and narrow side windows flanking the front door. (Courtesy Maureen Webb.)

The French Provencial home located at 3531 Chesapeake Avenue was built for Dr. Hunt in 1938. It incorporates many of the features common to French Provencial homes, including brick construction with copper detailing, the high hipped roof, and double French windows with shutters. (Courtesy Sean and Debbie Hancock.)

The house at 106 Cherry Avenue was built in 1914 by Dr. Hankins, whose son was a champion speedboat racer on the Chesapeake Bay in the 1930s. This home is a Dutch Colonial Revival with an atypical "L" shape. The gambrel roof is a common feature of the style. (Courtesy Sean and Debbie Hancock.)

The home at 2404 Chesapeake Avenue is an example of a Shingle-style home. It was designed by Capt. William Daugherty and built by Fuller and Moran in 1890 for Capt. Charles E. Hewins, one of the developers of Indian River Park. The house had running water utilizing a basement cistern to collect and filter rainwater. The water was pumped using windmill power to a storage tank located in the attic. (Courtesy Helen Sampson.)

A good example of a flat-roof contemporary-style home is this house located at 2218 Crescent Drive. It was designed and built in 1959 by Harry and Evelyn Penn, who owned Penn's Leather and Luggage, a well-known luggage store originally located in Newport News. The contemporary style usually includes lack of ornamentation and an unusual mixture of wall materials, such as the brick and wood seen here. (Courtesy Sean and Debbie Hancock.)

The home at 209 Cherry Avenue was built in 1931. The home is reminiscent of the famous Levitt homes built during the Great Depression and after World War II. These homes were simple mass-produced homes that gave many Americans the American dream of owning their own home. (Courtesy Sean and Debbie Hancock.)

Six

OLDE WYTHE'S REBIRTH

Starting in the 1970s, as the age of the neighborhood and its residents increased, much of Olde Wythe fell into disrepair. Fueled by racial integration tensions, the economic malaise of the 1970s, and the creation of new centers of commerce in Hampton Roads, Hampton and Olde Wythe fell prey to a common problem of the time—urban flight. The construction of the interstate highway system and the tunnels to the Southside of Hampton Roads further contributed to Olde Wythe's economic woes, drawing traffic away from Kecoughtan Road. As traffic along the old Route 60 thoroughfare of Kecoughtan Road fell, the businesses failed.

Today, however, the neighborhood has begun to experience a renaissance. With younger families returning to the neighborhood, many of the old homes are being restored to their original charm and glory. Residents are again investing in the community, and civic groups are again active.

While the neighborhood has experienced a rebirth, the nature of the community has experienced a change since the boom years. Many of the businesses along Kecoughtan are gone, never to return, as the area shifts to a more residential design. Most recently, the City of Hampton has formally agreed to a plan to redevelop many of the areas surrounding Olde Wythe along Kecoughtan Road, called the Kecoughtan Corridor Master Plan.

As Kecoughtan Road ceased as a main artery between Newport News and Hampton and the economies of Newport News and Hampton faltered, the small businesses along Kecoughtan Road failed. Throughout the 1970s, 1980s, and 1990s, many of the shops along the Kecoughtan corridor deteriorated. The above picture shows that many of the shops are gone, are empty, or are in a state of disrepair. (Courtesy Helen Sampson.)

On Monday, February 21, 1994, Officer Kenneth E. Wallace was shot while sitting in his police cruiser on Pocahontas Place. He later died. Officer Wallace was a 22-year peninsula resident and 7-year veteran of the Hampton police force. He was well known by the residents and merchants of Olde Wythe. His shooting was a great blow to the community. (Courtesy Helen Sampson.)

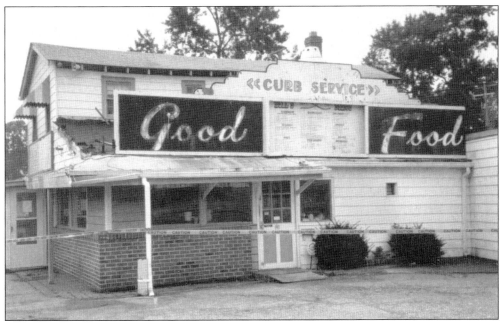

As the wrecking ball prepares to smash into Bill's Barbecue, it is symbolic of the nail in the coffin for the businesses along Kecoughtan Road. Bill's Barbecue was a local landmark and mainstay of the community. No longer would the Kecoughtan corridor be able to support its wide range of businesses. (Courtesy Fred Ferrari.)

The most damaging hurricane since 1933, Hurricane Isabel totally destroyed the 170-foot-long pier at 2308 Chesapeake Avenue on September 18, 2003. Isabel's wrath destroyed every pier along Olde Wythe's shoreline. The storm surge lifted 200-pound granite boulders from seawalls and deposited them 75 feet inland. Hurricane damage closed Chesapeake Avenue in front of Riverside Rehabilitation Center to through traffic for over a year. (Courtesy Mike McHenry.)

"Welcome to Olde Wythe," the Olde Wythe sign, sits at the entrance to the neighborhood at the intersection of La Salle Avenue and Kecoughtan Road. It is a welcoming symbol that speaks to the warm, friendly nature of the community, a community redeveloping itself. (Courtesy Sean and Debbie Hancock.)

This photograph shows the 2006 Olde Wythe Easter Egg Hunt—a celebration of life in Olde Wythe. Up to 100 children and their parents participate in this event, which has been held in Robinson Park for at least 25 years. The young families are busy tending gardens, renovating homes, and generally making the Olde Wythe of the future. (Courtesy Carol King.)

Today Olde Wythe is the scene of homeowners repairing the ravages of time with paint and landscaping, restoring architectural treasures to their original styles, and renovating their houses into new identities. This early-19th-century residence at 45 Greenbriar Avenue, originally a small farmhouse, is an example of a hybrid style changing with the times. In this 2005 picture, it is getting a new sunroom. (Courtesy Carol King.)

In 2003, Hurricane Isabel left many Olde Wythe homes flooded in its wake. As a result, many of the flood plains were reevaluated. The home being raised here is located at 305 Harbor Drive and overlooks Indian River Creek, which has been known to flood at high tide. (Courtesy Sean and Debbie Hancock.)

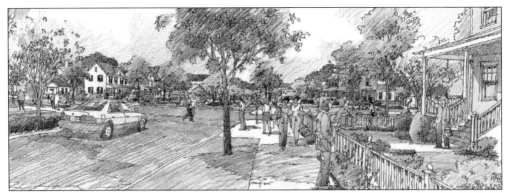

The newly adopted Kecoughtan Corridor Master Plan looks to redefine the worn-out area along Kecoughtan Road from a mostly abandoned commercial corridor to a primarily residential boulevard. The goal is to give the street the look and feel of a neighborhood main street while still preserving the charm and historic character of the neighborhood. (Courtesy Urban Design Associates, copyright 2005.)

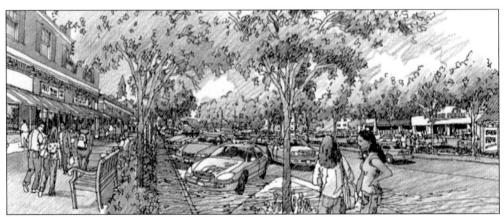

The new Kecoughtan Corridor Master Plan looks to move many of the sparsely located non-neighborhood-friendly commercial buildings along Kecoughtan Road to more defined and concentrated commercial nodes. It calls for updating the old Wythe Shops and giving the entire stretch of road a facelift. (Courtesy Urban Design Associates, copyright 2005.)

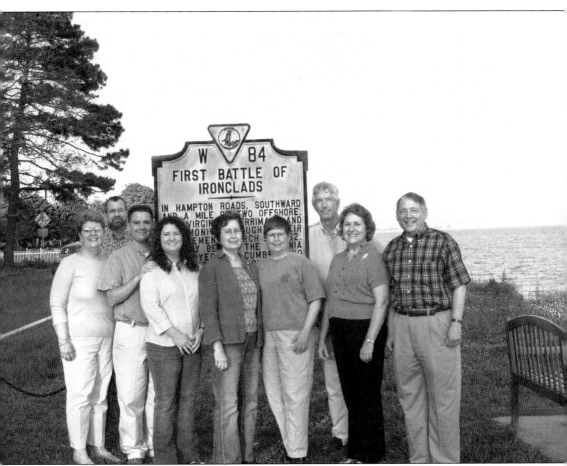

The Olde Wythe Neighborhood Association History Team is a diverse group. They are listed here from left to right. Ellen Melvin is a retired schoolteacher and fourth-generation Wythe resident. Gregory Siegel, originally from Buffalo, New York, moved here in 2000 and married a Wythe resident. Sean and Debbie Hancock came from Raleigh, North Carolina, in 2004, buying and restoring a 1920s Craftsman home on Algonquin Road. Helen Sampson is a professional photographer who grew up on Clifton Street, where her mother still lives. Carol King came to Wythe as an Air Force transient in 1985, returning in 2005 to Greenbriar Avenue upon retirement. Tom Norris grew up on Victoria Boulevard, spending his youthful spare time in Wythe. Today he lives in Smithfield and maintains an extensive collection of Wythe memorabilia. Janice Pratt McGrew grew up on Algonquin Road and Hampton Roads Avenue, married a career Air Force noncommissioned officer, and returned to Hampton in 1981. Mike McHenry served a career in the army, then moved to Wythe in 2001. He also serves as the current president of the Olde Wythe Neighborhood Association. (Courtesy Anne McHenry.)

ACROSS AMERICA, PEOPLE ARE DISCOVERING SOMETHING WONDERFUL. *THEIR HERITAGE.*

Arcadia Publishing is the leading local history publisher in the United States. With more than 3,000 titles in print and hundreds of new titles released every year, Arcadia has extensive specialized experience chronicling the history of communities and celebrating America's hidden stories, bringing to life the people, places, and events from the past. To discover the history of other communities across the nation, please visit:

www.arcadiapublishing.com

Customized search tools allow you to find regional history books about the town where you grew up, the cities where your friends and family live, the town where your parents met, or even that retirement spot you've been dreaming about.